Pissing Figures 1280–2014

David Zwirner Books

*ekphrasis*

Pissing Figures 1280–2014
Jean-Claude Lebensztejn

Translated by Jeff Nagy

# Contents

6
Little Julien

12
*Spiritelli*

30
Rabelais, 4.44

32
Lotto

38
Titian

48
Michelangelo

58
Sorel, *Francion*, Book 3

60
Pissing Girls

72
Modernities

82
Ambivalences

96
Schwarzenberg, *Büchlein vom Zutrinken*, Folio 92

98
Pissed Art

113
Figures

## Little Julien

The little bronze statue of a urinating boy that decorates a fountain in Brussels, universally known as Manneken-Pis, was commissioned in 1619 from Jérôme Duquesnoy the Elder (fig. 1). It replaced a stone figure dating from the fourteenth century, which, by the middle of the fifteenth, was known by the name 't Menneken-Pist, the boy (who goes) piss. *Manneke* or *menneke* is a Belgicism, the equivalent of the Middle Dutch *mannekijn*, a little man, which gave rise to the French word *mannequin*: denoting first a figurine or jointed statue; later, a man lacking in character; and, finally, a living male figure (1830) and then a female one (1897), employed in showcasing the designs of new fashion collections. In keeping with contemporary aesthetic criteria, they are now tall rather than diminutive.

All kinds of legends are associated with the origins of Manneken-Pis: some say the boy was dousing the lit fuse of an enemy cannon, or relieving himself in front of the home of a witch, or that he had been lost and then found "in the act" by his father, who presented the city with this votive statue. He became so popular that he was repeatedly stolen. (In 1913, the filmmaker Alfred Machin directed a short—featuring an eight-year-old Fernand Gravey and a five-year-old Balthus—in which the panther Saïda runs off with Manneken-Pis, fig. 2.) After the last theft, in 1965, a replica was installed in the fountain, and the remains of the original are now preserved in the Maison du Roi on Brussels's Grand-Place. Since the end of the seventeenth century, it's been a civic tradition to dress him up

on certain occasions: today, his wardrobe contains more than nine hundred different outfits. Like the *Mona Lisa*, he smiles; his pelvis juts forward, and his left hand lifts his little member higher than parallel to the ground, so that the refreshing stream flies as far as possible.

The degree to which little Julien, that being his first name, has become a kind of Belgian *Mona Lisa* (figs. 3a–3b) can be judged by his Japanese reception: in 1952, a dentist presented the city of Tokyo with a freely interpreted copy, in the form of a boy perched on a tall, rectangular pedestal, costumed as a fireman, or a baseball player, or wearing a traditional Japanese outfit complete with kimono, *tabi*, shorts, *hashimaki*, and fan. He fills a small rectangular basin bordered by flowers on a train platform at Hamamatsuchō Station (fig. 4). A half century later, in 2011, the Japanese corporation Sega developed a video game called *Toylet*, intended to be installed above urinals in public bathrooms. The game would measure the volume, force, and precision of a player's urinary stream (fig. 5). There are four versions, and one is named Manneken Pis.

Belgium's culture of excretion goes back centuries: from the shitting man who served as a symbol for Dinant (fig. 6), the birth city of Joachim Patinir, who occasionally used this emblem to sign his landscapes, or from the old proverb, illustrated by Bruegel (fig. 7), that warns against "pissing at the moon," up through Teniers and the series of canvases by Jordaens known as *The King*

*Drinks* that depicts an Epiphany feast, in some versions of which an old woman wipes a crying baby's ass, while in others the same baby pisses a vigorous, occasionally bifurcated stream, as a man vomits off to the left (fig. 8). In Brussels itself, toward 1435 or slightly later, Rogier van der Weyden, then the official painter of the city that produced little Julien, worked a man and a woman seen from behind into the background of his *Saint Luke Drawing the Virgin*, a motif he might have found in Van Eyck's recent *Madonna of Chancellor Rolin*. But here, the man seems to be pointing even farther off into the distance, at the minuscule figure of another man, also seen from behind, who pisses against the corner of a crenellated wall (figs. 9a–9c).[1]

Here we can see the outlines of an entire tradition preserved in popular imagery, a tradition that Baudelaire, while living in Brussels, pinpointed in his "M. Hetzel's Opinion on Faro" ("Faro, a synonym for urine!")—a synonymy that he elaborated in his *Article on cuisine. / Brussels Beverages*: "Faro is drawn from that great latrine, the Senne: a beverage extracted from the city's excrement by a distilling device. So for centuries the city has been drinking its own urine." Brasserie Lindemans describes faro as "a sweet, fruity, thirst-quenching Belgian beer. The favorite beer of women!" Brasserie Lefebvre, for its part, has decorated bottles of its white ale, produced in Brussels since 1989, with a Manneken-Pis urinating on the same wheat and hops the beer is brewed from.[2] A website devoted to rating beer describes it as:

pouring a light yellow color, on the clear side, with a head of more or less ordinary foam. Aromas of banana and orange, slightly sweet malt, and a dash of lemon. A hint of yeast in the background. In the mouth, you taste the lemon first, with yeast, malt, and coriander underneath. A bit of orange comes back in the final sips. Banana more subdued but still noticeable. The epitome of white beer.

The same Brasserie Lefebvre, in 2010, renamed one of its blonde ales Manneken Pils, The Belgian Spirit. The "i" in Pils is a Manneken-Pis with a red sun hovering above him.

In the era of women's rights movements, it was inevitable that the eminently—if modestly—virile symbol given form by Manneken-Pis would need to be shared more equitably: in 1985, Denis-Adrien Debouvrie, or Debouverie, the wealthy owner of restaurants and real estate in the touristy center of Brussels, presented the city with Jeanneke-Pis, a bronze statue of a young girl squatting to relieve herself. His comment on the gift: "We hereby achieve equality between Men and Women." In 2008, Debouvrie, then seventy-four years old, was found with his throat slit, dead in a pool of blood. The popular French-language tabloid *La Dernière Heure* let it be known that "Denis Debouvrie never attempted to hide his interest in young boys of North African origin." The manager of his restaurant the Little Fountain, T*** L***, fifty-four years old, was formally charged. As I write this in September 2013, the case is still ongoing, after an initial

dismissal and the opening of a new trial. On September 13, *La Dernière Heure* added, in an eloquent preterition, "We won't speak of the rest.... Not of Debouvrie's character, and not of his predatory sexual behavior targeting young boys, nor of the 'special' films of those boys that he made and hoarded." The paper does not specify whether or not these "special films" included any scenes paying homage to local folklore.

In 1998, Brussels installed, directly on the pavement, Zinneke-Pis, a dog lifting its leg to relieve itself against a post, where the Senne dear to Baudelaire still flows.

The natives of Brussels were proud to figuratively quench their thirst with little Julien's wee, but the authorities in seventeenth-century Flanders did not look kindly on love for young boys. In 1654, Jérôme Duquesnoy the Younger, son of the father of Manneken-Pis and brother to François, the most well-known member of this family of sculptors, was accused of committing sodomy with two of his apprentices. He was sentenced to death and executed in Ghent; his body was burned to ashes.

---

1   A detail pointed out to me by Guillaume Cassegrain.
2   Pictured in Eddy de Jongh, "De plassende Amor," *Kunstschrift*, no. 6 (2006): p. 28. With thanks to Carel Blotkamp.

*Spiritelli*

The Italianate style of Manneken-Pis is evidence that Northern Europe doesn't have a monopoly on the *puer mingens*, which is the Latin name scholars gave to the figure of a pissing child. A dash of Latin is not out of place here, as some late Roman sarcophagi, decorated with bacchanals of little cupids, also feature a urinating boy placed here or there among the general debauchery: in the Uffizi, he touches his penis with his right hand, his head turned toward his two neighbors, who cling to one another to keep themselves standing; at the Louvre, he holds it with his left, his right arm around the shoulders of his companion, who places his own right hand on the boy's chest (fig. 10).[1] A few scattered statues have survived as well, including a modestly ithyphallic Hermaphrodite in bronze, "who held before him in his two hands a shell or conch filled by the water that sprung from his penis, channeled through an interior conduit" (fig. 11).[2]

These relics from antiquity may have inspired artists of the Italian Renaissance in search of motifs for their countless groups of *putti*. Toward the middle of the fifteenth century, naked, urinating children began to crop up in the margins of illuminated manuscripts, often accompanied by young musicians playing drums, cornetti, or other wind instruments (figs. 12a–12b)[3]: an association already present in the earlier bacchic sarcophagi, like the one held by the Louvre, in which the pissing child, propping himself up against a neighbor, appears next to musicians equipped with wind and percussion instruments.

The motif of the urinating young boy gradually moved from the margins to the very heart of the image, spicing up the scenes where it appeared. In the sumptuous Grimani Breviary's *Month of February*, a boy, standing in a farmhouse doorway through which one can make out his parents, lets loose a yellow stream into the white snow, his breath turning to fog in the air (fig. 13).[4] And toward 1500, in one of the *Scenes from the Life of the Young Tobias* where the Florentine artist (perhaps Bugiardini?)[5] painted Tobias leaving the wedding banquet in a contemporary setting, among the other vignettes from daily life the painter placed in the foreground, one can see a little boy lifting up his robe to relieve himself in the street while two elegant pages, their arms around each other's waists, look on (figs. 14a–14b).

Diuretic fantasies also infiltrated sacred spaces, where piss could take on a purifying function. As early as the thirteenth century, in the south transept of the upper church of the Basilica of Saint Francis of Assisi, just above Cimabue's dramatic *Crucifixion* (c. 1280), the artist and his assistants placed three adult angels behind a colonnade. The figures are monumentally sized, with long wings and dressed in flowing robes, each holding a scepter in his right hand (fig. 15). While the fresco has degraded heavily over time, an attentive visitor can still make out that one of the angels holds his penis in his left hand through a circular opening in his robe. The entire bottom half of the third angel has disappeared, but the second angel's left hand is also positioned over his

genitals: as if they intended to wash the dying, crucified Christ with their own bodily fluids.[6]

During the Quattrocento, the nature of pissing angels changed. These later angels were younger and often depicted naked and cheerful, a shift incarnated in the figure of the *spiritello*. In the Tempio Malatestiano at Rimini, among the naked children decorating the frieze of the Chapel of Liberal Arts and next to the interlocking monograms of Sigismondo Malatesta and his mistress-turned-third-wife Isotta degli Atti, Agostino di Duccio or his workshop added a winged boy who holds his penis in his right hand, with a cornucopia nestled in his left arm (fig. 16). Out of the whole crowd of nude little angels, the sculptor endowed this figure alone with a fig leaf, as a kind of visual joke: the tip of the angel's little member pokes out from under it.[7] Pope Pius II, the sworn enemy of Malatesta, condemned the new cathedral and its mixture of pagan and Christian figures, commingled to such an extent "that [the cathedral] seems less a Christian church than a temple for demon-worshipping infidels."

In Florence, Andrea Cavalcanti (il Buggiano, the adopted son of Brunelleschi) and, later, Pagno di Lapo Portigiani sculpted four winged and smiling *putti* in two classically styled niches (figs. 17a–17b), as ornaments for the sacristies' basins, where the clerics of the cathedral rinsed their hands before celebrating a mass, with the work taking place between 1438 and 1445. They were called *spiritelli* in the documents, little spirits (or sprites or imps). This is also the term used in *The Dream of*

*Poliphilus*—"alcuni bellissimi spiritelli nudi" (2.14)—to designate the figures of small children engaged in the harvest, a motif that later reappears sculpted on the vase of a triumphal chariot. In Florence, they hold basins or spigots in front of their penises, so that the holy water seems to have its source in their streams of urine.[8] It's rare to find this kind of monumentality in the decoration of washbasins, but the cathedral already featured a number of playful or devious *putti*. When they appeared here and there in other churches, these figures provided commentary, after their own fashion, on some profane or sacred event: in Padua's Ovetari Chapel, where a young Mantegna crowned *Saint James Baptizing Hermogenes* with a frieze of *spiritelli* perched on garlands, one of the *spiritelli*, hanging from a garland near the top left of the canvas's frame, lets loose a long jet of urine, as if it were a bemused, symbolic paraphrase of the baptismal water poured by the saint onto the head of the kneeling magician (figs. 18a–18b).[9]

Processions of urinating children set about inundating paintings and sculptures in villas and public squares. Pissing boys in Renaissance fountains alternated with women spilling water from their nipples, a variant on the traditional approach, in which water streamed from human mouths, the maws of animals, or basins. The stream could follow a circuitous route: in the Kingdom of Naples, a now-destroyed fountain in the Villa La Duchesca routed its water from the breasts of the siren

Parthenope into the mouths of three *putti*, who in turn passed it through their penises.[10] In a fountain engraved in Ferrara around 1470–1480, two perched *putti* piss on a handful of cupids. One of their streams of urine splits in two: one half splashes into the mouth of a winged toddler seated on the edge of the basin, and the other lands in the cup the *amorino* holds in his left hand (fig. 19).[11] Unusual orifices were sometimes pressed into service as conduits. In Niklaus Manuel Deutsch's 1517 painting *Bathsheba at the Bath*, whose opposite side is *Death as a Mercenary Taking a Young Woman*, the fountain's water flows in and out of a series of propitiously positioned bodily cavities, including the assholes of two winged children (figs. 20a–20b). In the courtyard of Rabelais's Abbey of Thelema, "there was a magnificent fountain fashioned out of beautiful Alabaster. At its top, the three Graces held cornucopias, and spouted water from their breasts, mouths, ears, eyes, and other bodily openings."[12]

The spa town Lacaune-les-Bains, in the Tarn region, prides itself on its Font dels Pissaïres, planned in 1399 and completed in 1559, which displays at its peak four well-hung pissing men demonstrating the diuretic powers of the local water (fig. 21). A Florentine *putto*, carved from gray stone in the middle of the fifteenth century, lifts his shirt with his right hand and his penis with the left, grimacing slightly (fig. 22—a cheerier version of the *putto*, executed in marble, is in the collection of the Musée Jacquemart-André). In Arezzo, toward 1544, a very young Pierino da Vinci, the nephew of Leonardo, sculpted a

smiling young pissing boy in marble, destined for a fountain: in front of his organ, he holds a grotesque mask through the mouth of which his piss streamed out (fig. 23). At the Palazzo del Te, on the ceiling of the Sala di Psiche, Giulio Romano painted a *spiritello* pissing to the left of a nymph pouring water from a pitcher; the arc traced out by his stream of urine is positioned not far from the thicker flow that emerges from the pitcher's mouth (fig. 24). Giulio had previously painted a standing winged *amorino* pissing into a vase held by another, squatting nearby, in a work for the Villa Madama (fig. 25). On a piece of majolica, dated to 1525–1526 and attributed to Francesco Xanto Avelli da Rovigo, a blindfolded Cupid pisses from the summit of a fountain; Narcissus loses himself in the fountain's lower basin while Echo and a group of nymphs look on (fig. 26).[13] In France, René Boyvin (or Pierre Milan) produced an engraving of a decorative metal centerpiece after Léonard Thiry: a figured fountain depicting the story of Actaeon, on which eight *putti* spill water from conches or their penises into a basin decorated with shells (fig. 27).[14] In short, from the fifteenth to eighteenth centuries, in painting, engraving, and in public parks, the pissing child remained a figural commonplace for fountains (as well as for other settings: see Hogarth, *The Enraged Musician*, 1741, fig. 28;[15] Hubert Robert, *Laundress and Child*, 1761, fig. 29[16]). It is intriguing that Abraham Bosse, in his *Works of Mercy*, produced around 1635, chose to give drink to the thirsty in the form of water from a pissing *putto* (fig. 30).[17] Now, in the era of

indoor plumbing, we rarely if ever consume water like this, but the memory of the pissing child endures in popular culture (in Blake Edwards's 1968 film, *The Party*, a Manneken-Pis stands at the edge of the pool that serves as the film's main setting). And even today, eBay offers those who visit its site the opportunity to purchase a particular piece of garden décor, priced at four hundred and ninety-nine euros, that includes a "putto che piscia in polvere di marmo cm 145": a 145-centimeter-high fountain featuring a pissing *putto* made of reconstituted marble.[18]

Many of these fountains may have a common source in *The Dream of Poliphilus*. Published in 1499 in Venice by Aldus Manutius, this esoteric dream narrative relates how the eponymous hero, in the course of his adventures, meets five nymphs, incarnations of the five senses. The nymphs invite Poliphilus to bathe with them and lead him to a fountain decorated with sculptures of two nymphs lifting up the tunic of a child standing upright, a foot on one of each of their hands. "The Infant [held] his little Instrument in both his hands, and continued pissing into the hotte water, fresh coole water."[19] The nymphs ask Poliphilus to approach the fountain and fill a crystal vase from the boy's stream, but:

> I had no sooner set my foote vpon the steppe, to receiue the water, as it fell, but the pissing Boye lift vp his pricke, and cast sodeinlye so cold water vppon my face,[20] that I had lyke at that instant to haue fallen backwards. Whereat they so laughed, and it made

such a sounde in the roundnes and closenes of the bathe, that I also beganne (when I was come to my selfe) to laugh that I was almost dead.

Of course, a mechanism raised the "puerile instrument" whenever anyone set foot on the step. An elegant inscription in Greek letters on the fountain's frieze spelled out the word ΓΕΛΟΙΑΣΤΟΣ.[21] The Italian text leaves it untranslated, but the French edition of 1546 interprets it as ridiculous, or laugh inducing. The woodblock print in the Aldine edition shows a classical fountain and the two nymphs holding the naked child, who touches his penis with both hands, his legs spread (fig. 31). But in the French edition, the artist (Jean Goujon?) slightly alters the poses: now the child looks down to watch what he's doing. The artist also adds a long jet of urine, shooting out of the fountain from the end of the child's member (fig. 32). This illustration is preceded and followed in the book by two others, of fountains where water pours from the nipples of nude women.

(Between about 1636 and 1644, the young Eustache Le Sueur painted an ensemble of eight canvases intended for reproduction as tapestries and based on *Poliphilus*. The set included one corresponding to the scene in which the hero gets himself drenched by the child's stream of urine, executed in a magnificent style Le Sueur borrowed from his teacher, Vouet, and very different from the illustrations he might have seen in the book itself, republished in 1600 with the first translation's original plates.

The hero, a sort of Caracalla in classical drag, tries to fend off the water that spurts from the fountain, seen in three-quarters profile; the scene is fleshed out with five little sprites to correspond to the five nymphs [fig. 33]. The overall intention is to elevate the episode by gilding it with a conventional French stateliness while repressing its Rabelaisian undercurrents; the contemporary expert on Le Sueur describes the canvas as a "work of perfect grace, amusing but not vulgar." [22])

Contemporaneous with the French edition of *Poliphilus* in 1546, an etching by Jean Mignon after Luca Penni portrayed Diana and three nymphs bathing in a fountain at the moment Actaeon happens upon them (fig. 34). In keeping with Ovid's text, the goddess sprays the hunter with a jet of water that transforms him into a deer, while in the background, a naked child (a sculpture, but very lifelike) splashes a stream of his own making, sharply drawn, almost solid, onto the back of one of the nymphs. Below, two of the four dolphin-straddling *putti* positioned around the fountain's base seem to piss in concert. The decorated frame bears the words that Actaeon, his head transformed into a hind's, is no longer able to shout to his own hounds, now on the point of devouring him: "DOMINUM / COGNOSCITE / VESTRUM," know your master (*Metamorphoses*, 3.230). The extremely detailed etching—"one of the greatest successes of the era," according to Zerner [23]—was copied on a mantelpiece for the Hôtel Hugues Lallemant in Châlons-en-Champagne, later moved to the Château d'Écouen. The bas-relief

exhibits a number of variations on the original, but the urine is still there, sculpted in relief (fig. 35).

Although it can make us laugh—ΓΕΛΟΙΑΣΤΟΣ—the urinary stream also has apotropaic powers. In particular, it was often featured on the undersides of platters used to serve food and drink to Florentine women lying-in after childbirth. From the radiant genitals of *The Triumph of Venus* conserved in the Louvre, from Masaccio to Pontormo, a number of Florentine artists, often specialists in this kind of decorative houseware, painted both sides of these *deschi da parto*. One *desco da parto*, the work of Bartolomeo di Fruosino and dated 1428, shows on its recto the birth of Saint John the Baptist, and on the reverse a robust, naked small child, seated on a smooth rock in front of a forest scattered with flowers, pissing into a body of water (fig. 36).[24] He wears a coral amulet around his neck and holds in his hand a reel or top; a hobby horse is pressed between his left thigh and folded right leg. These two toys are listed in Ripa's *Iconologia* as the allegorical emblems for the caprices and diversions of children. An inscription runs the edge of the dodecagon: "I SONO VN BANBOLIN CHE SVL . . . A DIMORO FO LA PISCIA D'ARIENTO E D'ORO," I am a baby, who lives on [the island? the rock?]. I pee silver and gold.

Magic powers seem to have been ascribed to the urine and genitals of male infants. On the reverse of another birth salver, painted toward 1450 by Giovanni di Ser Giovanni, the brother of Masaccio, two naked toddlers

tug on one another's hair and *priapuli*; the infant presented face on, his cheeks flushed, smiles and winks at his adversary (fig. 37a). On another, by Apollonio di Giovanni, a naked boy pisses on a poppy's husk, a fertility symbol, held by another naked boy bending down in front of the first (fig. 37b); the artist had placed a *Triumph of Chastity* (after Petrarch) on its other side.[25] Beyond its practical function, the *desco da parto* was a priapic talisman of the first order.

The baby who pisses silver and gold—son of a jeweler, or of a banker?—synthesizes the developing child's stages of behavior as summarized by Freud in his preface for the 1913 German edition of John G. Bourke's *Scatalogic Rites of All Nations*:

> In the earliest years of infancy there is as yet no trace of shame about the excretory functions or of disgust at excreta. Small children show great interest in these, just as they do in their other bodily secretions; they like occupying themselves with them and can derive many kinds of pleasure from doing so. Excreta, regarded as parts of a child's own body and as products of his own organism, have a share in the esteem—the narcissistic esteem, as we should call it—with which he regards everything relating to his self. Children are, indeed, proud of their own excretions and make use of them to help in asserting themselves against adults. Under the influence of its upbringing, the child's coprophilic instincts and inclinations gradually

succumb to repression; it learns to keep them secret, to be ashamed of them and to feel disgust at their objects. Strictly speaking, however, the disgust never goes so far as to apply to a child's own excretions, but is content with repudiating them when they are the products of other people. The interest which has hitherto been attached to excrement is carried over on to other objects—for instance, from feces on to money [fig. 38], which is, of course, late in acquiring significance for children.[26]

A branch of the Düsseldorf Savings Bank still advertises precisely this transference: one of its walls bears a folkloristic image of the *Dukatenscheißer*, the shitter of ducats, a squatting man with his pants down, who gazes out of the frame at passersby while he shits gold coins into a sack. He simultaneously issues a disclaimer, written in gold letters, that when it comes to money it pays to be sober-minded and responsible: "THIS FAIRY TALE WILL NEVER COME TRUE / BE PRUDENT AND FRUGAL, AS LIFE TEACHES YOU" (fig. 40).

An equivalence between excrement and gold appeared in many of the most ambitious compositions of the Nordic Renaissance.[27] In *The Garden of Earthly Delights*, near the bottom right of the pane depicting hell, just underneath the large demon and next to a grayish vomiting figure, Bosch painted a pale, naked ass engaged in shitting gold coins into a well in which human heads struggle to the surface for air (fig. 41). Sixty years later, Bruegel

placed a large figure of indeterminate gender in the center of his *Dulle Griet* (*Mad Meg*). The figure, whose limbs are thin to the point of being skeletal, is seated on the roof of a house and carrying a boat topped with a glass globe in which trapped men gesticulate. Its backside is a large, cracked eggshell, from which it scoops out black coins with a long-handled ladle; groups of women waiting below to collect the coins shove and tussle with one another (fig. 42). The atmosphere is muddier and more obscure than the background of Bosch's hellscape. It's as if the painter were telling us: "This time, all Hell is here on Earth." In Bruegel, Bosch's golden coins are shown for what they really are: "We know that the gold which the devil gives his paramours turns into excrement after his departure, and the devil is certainly nothing else than the personification of the repressed unconscious instinctual life." [28]

Now that myths and money have both so quickly evolved, one could imagine that the globalized, excremental egg might soon be in a position to vacuum up the entire world, with the force of a black hole.

---

1   *Die Antiken Sarkophagreliefs*, vol. 5, part 2, fasc. 1, *Die Stadtrömischen Eroten-Sarkophage: Dionysische Themen*, ed. Peter Kranz (Berlin: Gebr. Mann Verlag, 1999). Uffizi sarcophagus: p. 136, cat. 12, and pl. 37, figs. 1, 3; Louvre sarcophagus: p. 141, cat. 36, and pl. 39, fig. 1. Both date from the end of the third century.

2    Waldemar Deonna, "Fontaines anthropomorphes. La femme aux seins jaillissants et l'enfant 'mingens,'" *Genava*, no. 6 (1958): p. 263 (and the entirety of the article, pp. 239–296). See also Salomon Reinach, *Cultes, mythes et religions*, vol. 2 (Paris: Ernest Leroux, 1906), pp. 335–337.

3    Vatican manuscripts Urb.lat.258 (musical treatise); Vat.lat.888 (*Commentary* of Duns Scotus); Vat.lat.1145 (pontifical); Urb.lat.277 (Ptolemy's *Geography*). See Augusto Campana, "*Pueri mingentes* nel Quattrocento," in *Friendship's Garland: Essays Presented to Mario Praz on His Seventieth Birthday*, ed. Vittorio Gabrieli, vol. 1 (Rome: Edizioni di storia e letteratura, 1966), pp. 35–39.

4    *Le Bréviaire Grimani* (Brussels: Arcade, 1977), pl. 3, fol. 2v.

5    An attribution rejected by Laura Pagnotta, *Giuliano Bugiardini* (Turin: Allemandi, 1987), cats. 80–81.

6    Pointed out by Arno Haijtema, a journalist for *de Volkskrant*, to Carel Blotkamp, who passed the information on to me. See Luciano Bellosi, *Cimabue* (Milan: Motta, 2004), p. 185; Donal Cooper and Janet Robson, *The Making of Assisi* (New Haven, Connecticut: Yale University Press, 2013), p. 85, fig. 85. These authors do not comment on the angels mentioned in the text above.

7    Campana, "*Pueri mingentes* nel Quattrocento," p. 33. In a note on p. 42, the author lists other examples from fifteenth-century Tuscan sculpture. See also Angelo Turchini, *Il Tempio Malatestiano: Sigismondo Pandolfo Malatesta e Leon Battista Alberti* (Cesena: Il Ponte Vecchio, 2000), pp. 447, 449.

8    Margaret Haines, *The "Sacrestia delle Messe" of the Florentine Cathedral* (Florence: Cassa di Risparmio, 1983), pp. 124–126, and p. 116, figs. 74–75; Marilyn Aronberg Lavin, "Art of the Misbegotten: Physicality and the Divine in Renaissance Images," *Artibus et Historiae* 30, no. 60 (2009): pp. 198–207. On the *spiritelli*, see Charles Dempsey, *Inventing the Renaissance Putto* (Chapel Hill: University of North Carolina Press, 2001). The term, which appears in Dante's *Vita nuova* and *Convivio*, is often used in the Quattrocento to designate the impish and usually winged young boys popularized by Donatello and a handful of others.

9    Keith Christiansen, *Andrea Mantegna: Padua and Mantua* (New York: George Braziller, 1994), pp. 26–27; p. 27, fig. 12. The chapel was destroyed by an Allied bombardment in 1944. David Monteau brought to my attention the *Liber medicine orinalibus*, a medieval treatise attributed to Hermogenes of Smyrna, a doctor in the school of Erasistratus in the first century. See Faith Wallis, "Signs and Senses: Diagnosis and Prognosis in Early Medieval Pulse and Urine Texts," *Social History of Medicine* 13, no. 2 (2000): pp. 272–273.

10   George L. Hersey, *Alfonso II and the Artistic Renewal of Naples 1485–1495* (New Haven, Connecticut: Yale University Press, 1969), p. 71; Lavin, "Art of the Misbegotten: Physicality and the Divine in Renaissance Images," p. 236.

11   See Patricia Simons, "Manliness and the Visual Semiotics of Bodily Fluids in Early Modern Culture," *Journal of Medieval and Early Modern Studies* 39, no. 2 (2009): pp. 346–347.

12   François Rabelais, *Gargantua* (1534), chap. 55. Cf. the fountain with the three Graces in *The Dream of Poliphilus*, 1.8; in chap. 9 of *Gargantua*, Rabelais mentions *Orus Apollo* and *Poliphilus* in the same sentence.

13   Brought to my attention by Anouk Jevtić.

14   *The French Renaissance in Prints from the Bibliothèque Nationale de France*, exh. cat. (Los Angeles: Grunwald Center for the Graphic Arts, University of California, Los Angeles, 1994), pp. 318–320 (text by David Acton).

15   Called to my attention by Henri Zerner.

16   Brought to my attention by Augustin de Butler.

17   My thanks to Nina Serebrennikov, who identified this image for me.

18   I'm grateful to Éric Michaud, who mentioned other French pissing figures: at Peyrusse-le-Roc, in Aveyron; in Albi, in the Maison Enjalbert; a fountain with four pissing boys in front of the archiepiscopal residence in Toulouse; another in Rouen, backed against the Église Saint-Maclou. My gratitude as well to David Monteau, who dug up many other examples of pissing figures.

19   *Hypnerotomachie, ou Discours du songe de Poliphile*, 1.8, trans. Jean Martin (Paris: Jacques Kerver, 1546), fols. 27–28. [Translator's note: The English text above is not an original retranslation of the French edition, which is slightly fuller here, but comes from the 1592 English translation by Robert Dallington.]

20   In the original Italian, the phrase runs: "il mengore levoe el priapulo e nella calda facia trassemi l'aqua frigidissima," the pisser lifted his willy and cast freezing cold water into my hot face. The text plays on the opposition between "calda facia" and "aqua frigidissima." Some commentators have read "mengore" as the subject and "priapulo" as the object, and others have read the sentence with the syntax inverted: as if the subject and object, the whole and the part, could be substituted one for the other. See Marco Ariani and Mino Gabriele, ed. and trans., *Hypnerotomachia Poliphili*, vol. 2 (Milan: Adelphi, 1998), p. 688; Campana, "*Pueri mingentes* nel Quattrocento," p. 411n1. [Trans. note: As above, the English text is from the 1592 translation by Dallington.]

21   Apparently a hapax legomenon, combining the Greek adjectives γελοίος and γελαστός, signifying laughable or pleasant, with the noun γελοιαστής, meaning clown or joker.

22    Alain Mérot, *Eustache Le Sueur: 1616–1655* (Paris: ARTHENA, 1987), p. 165 (description of *Polyphile au bain avec les Nymphes*). See also Anthony Blunt, "The *Hypnerotomachia Poliphili* in 17th Century France," *Journal of the Warburg Institute* 1, no. 2 (October 1937): p. 131. Blunt also mentions other pissing *putti* in seventeenth-century painting: in Poussin, *Le frappement du rocher* (Bridgewater version), Bourdon, Castiglione, Annibale Carracci …

23    Henri Zerner, *L'art de la Renaissance en France* (Paris: Flammarion, 1996), p. 131.

24    Andrea Bayer, ed., *Art and Love in Renaissance Italy*, exh. cat. (New York: The Metropolitan Museum of Art, 2008), p. 66, fig. 54 (text by Deborah L. Krohn); pp. 152–153, cat. 69 (text by Jacqueline Marie Musacchio). A variation on this infant can be found in Jacqueline Marie Musacchio, *The Art and Ritual of Childbirth in Renaissance Italy* (New Haven, Connecticut: Yale University Press, 1999), p. 40.

25    Bayer, *Art and Love in Renaissance Italy*, pp. 157–159, cats. 71–72 (text by Jacqueline Marie Musacchio); Keith Christiansen, "Lorenzo Lotto and the Tradition of Epithalamic Paintings," *Apollo* 124 (September 1986): p. 171; Cecilia de Carli, *I deschi da parto: E la pittura del primo Rinascimento toscano* (Turin: Allemandi, 1997), pp. 144–145.

26    Sigmund Freud, *The Standard Edition of the Complete Psychological Works of Sigmund Freud*, trans. James Strachey, vol. 12, *1911–1913: The Case of Schreber, Papers on Technique and Other Works* (London: The Hogarth Press, 1958), pp. 333–338. In a letter to Fleiss dated January 24, 1897, as in his "Character and Anal Erotism" (1908), Freud explicitly mentions the *Dukatenscheißer*, which appeared here and there in Germany—on the façade of the Hotel Kaiserworth in Goslar, Lower Saxony, for instance (fig. 39).

27    As is often the case in Bosch, the depiction of urine is heavily symbolic. See the case of the man who relieves himself against a brothel while a couple embrace in the doorway, in *The Vagabond* in Rotterdam, or, in *The Last Judgment* in Vienna (possibly a copy), the drunk whose punishment consists of being forced to drink urine poured into his mouth from a cask, while the cask itself is continuously refilled by an enormous dick, imprisoned in a turret and pissing through a grate into a funnel.

28    Sigmund Freud, "Character and Anal Erotism," in *The Standard Edition of the Complete Psychological Works of Sigmund Freud*, trans. James Strachey, vol. 9, *1906–1908: Jensen's 'Gradiva' and Other Works* (London: The Hogarth Press, 1959), pp. 167–176.

*Just so, quoth Panurge, Jenin Toss-pot of Quinquenais, evac-
uating some wine of his own burning on his wife's posteriors,
laid the ill-fumed wind that blowed out of their centre as out
of some magisterial Aeolipile. Here is a kind of a whim on
that subject which I made formerly:*

*One evening when Toss-pot had been at his butts,
And Joan his fat spouse crammed with turnips her guts,
Together they pigged, nor did drink so besot him
But he did what was done when his daddy begot him.
Now when to recruit he'd fain have been snoring,
Joan's back-door was filthily puffing and roaring;
So for spite he bepissed her, and quickly did find
That a very small rain lays a very high wind.*

*François Rabelais,* Gargantua and Pantagruel, *4.44, "How
small rain lays a high wind."* [1]

---

1   In the collegiate church at Champeaux, in Seine-et-Marne, one of the
    stalls created by the Parisian carpenter Richard Falaise in 1522 depicts
    a boy pissing vigorously into a large winnowing basket (in French, *un
    grand van*), perhaps as a pun on the proverb "Petite pluie abat grand
    vent" (fig. 43). [Trans. note: The English translation is that of Sir Thomas
    Urquhart and Peter Anthony Motteux, published in London by James
    Woodward in 1708.]

# Lotto

The image of a pissing boy seems to have carried promises of prosperity, fiscal as well as physical. Lorenzo Lotto's *Venus and Cupid*, painted, so scholars believe, in the years between 1525 and 1530, is an elaborate allegorical composition (fig. 44).[1] At the left, a naked Cupid in high spirits and lightly grotesque, with spread wings, a quiver slung over one shoulder, and crowned with myrtle, the plant sacred to Venus, grasps a second myrtle crown from which dangles a censor. The crown hangs at the end of a blue cord, delicately held by a recumbent Venus on the right side of the painting. She is nude except for a tiara and a band that encircles her torso just beneath the breasts, with rose petals scattered over her pubis and thighs. With his right hand, the child lifts his little member high and lets loose a stream of urine ending in individual droplets, which passes through the crown to land directly on the *mons veneris* of the maternal Venus. The subtext of their amused exchange seems to be: nice shot! Reclining under a hanging conch, Venus smiles slightly, her hair covered by a bridal veil, a sapphire and a pearl hanging from her left ear, and her left hand touching her breast; her face, seemingly a portrait, tilts down but still faces out toward the spectator, as if her gaze itself were suspended from an invisible cord. Freighted with subtle hazards—at the extreme bottom right of the canvas, a serpent slides through the grass, emerging from underneath the blue cloth on which Venus reclines—the painting is evidently an epithalamion, celebrating a wedding: the child's urine, a source of harmless amusement charged with powers

related to fertility, appears as an innocent and represent-able substitute for the concealed semen of a mature man (an equivalence that Michel Dorigny, in the seventeenth century, and Jacques-Antoine Vallin, at the beginning of the nineteenth, brought fully to light in their paintings of fountains ornamented with pissing *putti* [*Diana Discovering the Pregnancy of Callisto*, fig. 45; *Three Nymphs next to the Fountain of Love*, fig. 46; *Charmante Gabrielle . . .*, fig. 47]). Lotto's nuptial urine is composed of both silver and gold: the two precious metals intertwine in the juvenile stream.

In 1524, commissioned to decorate the Suardi Oratory in Trescore, near Bergamo, Lotto painted, among other scenes, a mystical grapevine with Christ as the rootstock and, on the ceiling, a grape harvest conducted by naked children bearing banners (fig. 48a). One of them, seen from below, grips his ballsy little instrument with two hands and directs an enthusiastic jet of piss toward the spectator (fig. 48b); at the time the painting was made, he would have been aiming at the holy-water font. A similar motif had already appeared a quarter of a century earlier, in the *bellissimi spiritelli* on the triumphal chariot in *The Dream of Poliphilus* mentioned above (fig. 49): "vpon the top of the frame there were little naked boies, climing vp and sitting aloft gathering the ripe clusters: others offering them in a basket to the God, who pleasantly receiued them: other some lay fast a sleepe vpon the ground, being drunke with the sweet iuice of the grape. Others applying themselues to the worke of mustulent autumne: others singing and piping." [2] The accompanying print

adds to the scene a nude child, perched on the side of a vase and pissing on the ground, holding his penis in his left hand. Lotto's adaptation in the oratory invested the harvest with a Eucharistic symbolism intended to check the Lutheran advances in the area, emphasized by banners inscribed with Bible verses on the vine, wine, blood, and childhood: "Go and work today in the vineyard"; "Unless you change and become like little children"; "Whoever eats my flesh and drinks my blood has eternal life," etc.[3] But Lotto, always fond of riddles, endowed the little pisser of Trescore with a jet of urine as green as the foliage that surrounds him: perhaps we can see here an invocation of the green lion, the alchemical dew? Pissing figures appear at least six times in Lotto's work. At the Basilica di Santa Maria Maggiore, Bergamo, in the marquetry, dated to 1527, that depicts the story of Judith and Holofernes, just above a group of Assyrian soldiers collapsed into drunken sleep, a man pisses (in inlaid drops!) while two other men shit nearby (fig. 50). Some have seen here an allusion to the vulgarity and brutality of German soldiers during the recent sack of Rome.[4]

Upon his return to Venice that same year, Lotto painted the portrait of merchant and collector Andrea Odoni: wearing a full beard and with a confident demeanor, he holds a bust of Diana of Ephesus in his right hand, while his left presses the crucifix he wears around his neck; among the antiquities that surround him, we can see three sculpted images of Hercules, including, at the far right, a smaller statue of Hercules drunk and pissing (fig. 51).

This is a motif that appeared in statues from Roman antiquity, passed down through time in copies and imitations (fig. 52), including versions by Bandinelli, Rubens, and others. Later, toward 1540, Lotto inserted in a *Toilet of Venus* (perhaps a copy) a fountain with a woman lifting up a naked child who pisses into a basin, his thighs spread wide, holding his penis with two hands (figs. 53a–53b).[5] In 1543, he sketched yet another naked, pissing *putto* on the back of a drawing of Saint Peter and Saint Paul lifting up a monstrance (fig. 55). What sets these images apart, as with the art of Lotto in general, is the characteristic mixture of humor and hermeticism pointed out by Zanchi.[6] Lotto seems to have been keenly interested in alchemy, where urine plays an important role, and in the illustration of hermetic symbols, of which the wooden covers in the basilica's choir provide so many stupefying examples (see fig. 74). One of the ambitions of this provincialized Venetian was perhaps to re-create the allegorical art of the *imprese* on a grand scale; a goal he shared with Rosso, that other great painter-in-exile.

1   Christiansen, "Lorenzo Lotto and the Tradition of Epithalamic Paintings," pp. 166–173; *Le siècle de Titien*, exh. cat. (Paris: Réunion des musées nationaux, 1993), pp. 494–495 (text by Sylvie Béguin); Bayer, *Art and Love in Renaissance Italy*, pp. 321–323, cat. 148 (text by Andrea Bayer).

2   *Hypnerotomachie*, fols. 61–62. See also Ariani and Gabriele, *Hypnerotoma-chia Poliphili*, vol. 1, p. 175. [Trans. note: As in previous citations from *Poliphile*, the English text above is from the Dallington translation. The passage quoted by the author, as rendered in French by Martin, could be translated into modern English as: "Some treaded on the grape harvest, others loitered, beating on timbrels, and singing out of key. Many had lain face-down directly on the ground, put to sleep from having raised one too many glasses, and drunk from the sibyl of the wine press."]

3   Carlo Pirovano, ed., *Lorenzo Lotto: Les fresques de Trescore*, trans. Louis Bonalumi (Paris: Gallimard, 1998), p. 121 (inset). My gratitude to Mauro Zanchi for his comments on this detail.

4   Francesca Cortesi Bosco, *Il coro intarsiato di Lotto e Capoferri per Santa Maria Maggiore in Bergamo*, vol. 1 (Bergamo: Credito Bergamesco, 1987), p. 474; Mauro Zanchi, *La Bibbia secondo Lorenzo Lotto* (Clusone: Ferrari, 2003), p. 40.

5   Pietro Zampetti, "Un capolavoro del Lotto ritrovato," *Arte veneta*, no. 11 (1957): pp. 75–81. Three centuries later, the motif of the mother who helps her child piss was taken back up by Millet in a peasant context (*Maternal Care*, c. 1855–1857, fig. 54; brought to my attention by Francesco Galluzzi).

6   See Mauro Zanchi, "Lotto: I simboli," *Art e dossier*, no. 275 (March 2011): pp. 21–31.

# Titian

Andros, as Fritz Saxl reminds us, is an island at the northern end of the Cyclades whose mountainous landscape was home to highly regarded vineyards.[1] The isle was sacred to Dionysus; according to Pliny the Elder (2.231, 31.16) and Pausanias (6.26), each year on the Nones of January, a spring housed in the island's temple flowed with water transmuted to wine; but, should anyone carry it off of the temple grounds, the wine was instantly converted back to water.

Toward 200 CE, the Greek rhetorician Philostratus, author of *Apollonius of Tyana*, wrote the first book of his *Imagines*, a series of ekphrases of paintings, real or imagined, among which one could find a description of a canvas representing the Andrians "drunk on the river of wine that flows through their island.... It was for the Andrians' sake that Dionysus made the earth laden with vines burst open, so that a river spilled forth for them."[2] The Andrians are there with their wives and children, crowned in ivy and greenbriers, some dancing, others stretched out on the ground, still others singing songs in praise of the river that, as it flows, fills everything in their land with beauty and strength. Flowing over a bed of grapevines, the river's rubicund water rushes past as mermen come to fill their conches; some of them drunkenly begin to dance. Dionysus arrives on a visit to his isle; his boat is in the harbor, bringing with it satyrs, bacchants, sileni, and Laughter and Comus, the Greek god of joy, "the best companions of drunkenness."

Four years after *Poliphilus*, Aldus Manutius published the Greek text of Εἰκόνες; Demetrios Moschos translated it into Italian some years later for Isabella d'Este, who thought so highly of it that she asked her brother Alfonso, the Duke of Ferrara, to return the volume on a number of occasions. When Alfonso wanted to decorate his *camerino d'alabastro* with a group of paintings by the best artists of the time, he appealed to Michelangelo, Raphael, Fra Bartolomeo, and Giovanni Bellini; after a series of complications and setbacks, the project was finally carried out by Bellini, Dosso Dossi, and Titian.[3] Titian found himself principally responsible for this vast undertaking; he retouched Bellini's landscape, *The Feast of the Gods*, and added three large canvases, *Bacchus and Ariadne*, *The Bacchanal of the Andrians* (fig. 56), and *The Worship of Venus*. For the latter two, Titian and his patron Alfonso drew on Philostratus's *Imagines*. Reproductions of classical paintings on the sole basis of their descriptions were highly prized: it was due to this fact that the *Calumny* of Apelles, described by Lucian of Samosata and transmitted by Alberti, inspired Botticelli and a number of other artists, from the Renaissance to the eighteenth century. In a written reply to Alfonso d'Este, Titian declared himself delighted at the thought of painting after classical ekphrases: "I assure you, my most illustrious Lord, that you could not ask of me anything more agreeable and more in keeping with my own heart."[4] Titian himself customarily referred to his mythological compositions as *poesie*.

Titian departed from Philostratus's text further in the *Bacchanal* than in his *Worship of Venus*. The river of Andros is an old man sprawled on a bed of grapes at the summit of a mound in the background; Bacchus is only present in the form of the white sail of his boat on the horizon, as he was already the central figure in *Bacchus and Ariadne*, hung next to this canvas. The singers sing an enigmatic canon—the riddle's solution is not given—whose text in French proclaims, "He who drinks and does not drink again / Does not know what drinking is": Adrian Willaert, head musician in the court of Ferrara in 1524, was the likely author.[5] Relying as it does on the staggered repetition of a central theme, the canon form itself offers a musical equivalent for "drinking again." Other figures drink, dance, serve wine, rub up against one another. In the foreground, a naked woman has fallen asleep, her right arm folded behind her head; nearby, a small boy lifts up his garment and pisses into the dark currents at the woman's feet.

The boy is the only child in the *Bacchanal*, but as the neighboring canvas, *The Worship of Venus*, was full to bursting with naked cupids, Titian reduces the crowd of Andrian children mentioned by Philostratus to this unique figure. The sleeping nymph and the pissing child are the painter's own inventions, and it was these two figures that caught the attention of contemporary viewers. When the contents of the *camerino* were brought to Rome by Cardinal Pietro Aldobrandini in 1598, a letter described the *Bacchanal* in these terms: "another painting by the

hand of the above-mentioned Titian which depicts a na-
ked, reclining woman with a toddler who pisses on her
feet, and other figures."[6]

Saxl saw a connection between Titian's toddler and
a figure on a second-century Roman sarcophagus con-
served in the Louvre, where one can see a winged child,
the only one wearing clothing in a group of nude children,
lift up his tunic with his left hand while his right presses
against a pedestal, a motif also found on a contempora-
neous sarcophagus in the Palazzo Mattei in Rome.[7] Titian
seems to have wanted to fill out the account given by
Philostratus with various classical and modern figures—
including drawing on Michelangelo's *Battle of Cascina*—
while also making use of *Poliphilus*. The sleeping woman
is a mirror-image version of the nymph that, accompanied
by a satyr, figured on a fountain Poliphilus encounters
in the chapter preceding the fountain with the pissing
child (fig. 57):

> And this excellent Image was so difinitelye expressed,
> that I feare mee *Prapitiles* neuer perfourmed the lyke
> for *Venus*, to *Nichomides* the King of *Caria* which Idoll
> he appointed to be adored of his subiects, although
> the beauty therof were such that it moued that filthie
> people to fleshly concupiscence.
>
> But I was perswaded that the perfection of the im-
> age of *Venus* was nothing to this, for it looked as if a
> most bewtifull Ladye in hir sleep had beene chaunged
> into a stone, hir hart still panting and hir sweete lipps

readie to open, as if she would not be so vsed....

...Vnder this rare and woonderfull carued woork betwixt the gulatures and unduls in the plaine smothe was grauen in *Atthic* characters this poesye:

/ ΠΑΝΤΩΝ ΤΟΚΑΔΙ. / [To the mother of all things.][8]

Cold water pours from the nymph's right breast, and hot water from her left. Her pose recalls that of the *Sleeping Ariadne* held in the Vatican, her body mostly cloaked under folds of Roman marble. The figure is stripped in *Poliphilus* but with a veil over her pubis, and totally naked except for a veil over her left arm in Titian's canvas. Later, when the painting had been moved to Rome, her genitals were covered with a sprig of ivy; she was returned to her original nudity by the Prado's restorers around 1900.[9]

For the pissing child, Titian could have drawn not only on the treacherous fountain in chapter 8 of *Poliphilus*, but also from the last of the four triumphal chariots in chapter 14. These chariots, fashioned from priceless materials, are drawn respectively by six lascivious centaurs, six white elephants, six ferocious unicorns, and six rust-spotted Hyrcanian tigers. The final chariot carries a precious, gem-encrusted vase, decorated on one side with Jupiter and seven nymphs progressively metamorphosed into trees, and on the other with a scene of children conducting a harvest under the direction of the god Bacchus, pictured here as "a young, pudgy god, with a face that resembles a woman's, crowned with two serpents," *uno festivo*

& *jucondo Nume, cum sembiante di una lubrica fanciulla.*
*Spiritelli*, of the sort mentioned above in relation to
Lotto's frescoes at Trescore, participate in the harvest
while Bacchus looks on (see figs. 48a–48b). The illustra-
tion, including the little pisser not described in the text
(we also find him, forty years earlier, in the *Harvest* of
Donatello, on the triangular base of *Judith and Holofernes*,
fig. 58), perhaps inspired, a quarter century later, both
the pissing child of Trescore and Titian's in the *Baccha-
nal* at Ferrara.

The skull of Titian's pissing child is curiously elongated,
under a crown of ivy and little blue flowers—periwinkle
perhaps? Moschos translated the *smilax* in Philostratus's
text as *salvia*, sage.[10] The boy's shoulders are bare and
his eyes are lowered as he lifts his white tunic with two
hands and, without touching his penis, pisses a stream
flecked with luminous highlights into the little river of
wine that flows between him and the sleeping nymph.
Downstream to the right, a naked man, whose face turns
toward the child, fills a jug from the adulterated current.
Absorbed in his own action, the child is caught in a dou-
ble cycle: that of the ages of human life that Panofsky sees
in the canvas of the *Andrians*;[11] and that of absorption-
excretion, which Rubens revives in the following cen-
tury—not in his loose copy of Titian's canvas, where the
child does not piss at all (fig. 59), but in the *Bacchus* held
at the Hermitage, an androgynous Bacchus suffused with
fat (fig. 60). Seated on a barrel with his foot resting on a
tiger, he is accompanied by Silenus, a maenad, and two

*putti*, one who greedily swallows the white wine that escapes from the tottering cup lifted by the god, while the other, violently drunk, lifts up his shirt to piss. The to-and-fro in Rubens's *Bacchus* is condensed further in Guido Reni's *Drinking Bacchus*, in Dresden (fig. 61), where the god drinks bright red wine from a carafe at the same time that he pisses on the ground ("the little naked Bacchus who returns immediately what he drinks"),[12] the stream of his urine parallel to the stream of wine spilling from the barrel against which he reclines. These canvases are charged with the kind of levity that *The Dream of Poliphilus* associates with urinary inundation. But in Titian, the child, who barely smiles, is far from being a figure of ridicule: he does what he has to do with a seriousness that characterizes in general the artist's *poesie*, and which finds its apex in the meditative old man of *The Flaying of Marsyas*. There's a certain reticence to the revels of all these inebriated Andrians. When Rubens paraphrased the *Bacchanal*, he completely transformed it, giving it a more earthly aspect (see fig. 59). The sprawling old river and the sheet bearing the words and music of the canon (*He who drinks and does not drink again*) have disappeared, the man bending down to pour wine has the attributes of Bacchus, and the nymph, her genitals again covered, seems to snore. The child, no longer crowned, lifts his tunic but does not piss, or does not yet, and the current of the stream, diverted toward the near foreground, has become clear water: it's only in the cup and the carafes that water is transformed into wine.[13]

1    Fritz Saxl, "A Humanist Dreamland," in *A Heritage of Images: A Selection of Lectures by Fritz Saxl*, ed. Hugh Honour and John Fleming (Harmondsworth: Penguin, 1970), pp. 89–104.

2    See also the translation, with commentary, by Blaise de Vigenère, *Les Images ou Tableaus de platte peinture* (1578) (Paris: Champion, 1995), pp. 361–369. [Trans. note: The French reference for this passage is to Philostratus the Elder, *La galerie de tableaux*, 1.25 (Paris: Les Belles Lettres, 1991), pp. 49–50. The English text that here occurs is a direct translation of the French edition's citation, which slightly modifies the text of the cited French edition of Philostratus. The text of the English Loeb edition is substantially similar, although the order of phrases differs.]

3    Beverly Louise Brown, "On the Camerino," in *Bacchanals by Titian and Rubens*, ed. Görel Cavalli-Björkman (Stockholm: Nationalmuseum, 1987), pp. 50–51.

4    Lionello Puppi, ed., *Tiziano: L'epistolario* (Florence: Alinari 24 Ore, 2012), p. 42.

5    Edward E. Lowinsky, "Music in Titian's *Bacchanal of the Andrians*: Origin and History of the *Canon per Tonos*," in *Titian: His World and His Legacy*, ed. David Rosand (New York: Columbia University Press, 1982), pp. 191–282.

6    Annibale Roncaglia, December 1, 1598; quoted in Charles Hope, "The Camerino d'Alabastro: A Reconsideration of the Evidence," in Cavalli-Björkman, *Bacchanals by Titian and Rubens*, p. 25.

7    Saxl, "A Humanist Dreamland," figs. 125–126; Kranz, *Die Stadtrömischen Eroten-Sarkophage*, Louvre sarcophagus: pp. 142, cat. 39, and pl. 4, figs. 2–3; Palazzo Mattei sarcophagus: pp. 151–152, cat. 82, and pl. 5, figs. 1, 4.

8    [Trans. note: English translation from the 1592 edition by Dallington. In a footnote, here omitted, Lebensztejn points out that the French translation by Martin somewhat censors the original's allusion to the Venus of Praxiteles. The Dallington renders this allusion more closely, i.e., that the Venus "moved those filthy people to fleshy concupiscence."]

9    Alfonso E. Pérez Sánchez, "*La Bacanal* y *La Ofrenda* a la diosa de los amores del Museo del Prado," *Nationalmuseum Bulletin* (Stockholm) 11, no. 2 (1987): p. 95.

10   Michaela J. Marek, *Ekphrasis und Herrscherallegorie* (Worms: Wernersche Verlagsgesellschaft, 1985), p. 135; the translation of Moschos used by Titian is held in the Bibliothèque Nationale de France, ms. Ital. 1091.

11   Erwin Panofsky, "Reflections on Time," in *Problems in Titian, Mostly Iconographic* (New York: New York University Press, 1969), pp. 101–102.

12    Carlo Cesare Malvasia, *Felsina pittrice: Vite de' pittori bolognesi*, vol. 2
      (Bologna: Barbieri, 1678), p. 91.
13    David Rosand, "An Arc of Flame: On the Transmission of Pictorial Knowl-
      edge," in *Bacchanals by Titian and Rubens*, pp. 88, 91; Görel Cavalli-Björkman,
      "Worship of Bacchus and Venus: Variations on a Theme," in *Bacchanals
      by Titian and Rubens*, pp. 100–101; Philipp P. Fehl, "Imitation as a Source
      of Greatness: Rubens, Titian, and the Painting of the Ancients," in *Bac-
      chanals by Titian and Rubens*, p. 119 et seq.

# Michelangelo

What was the impact of Titian's *Bacchanal*? Could Rosso have seen it before traveling to France, when he was en route from Borgo San Sepolcro to Venice in 1530? Some years later, he introduced the motif of the *putto* lifting up his clothes next to a woman asleep with her arm raised into his *Loss of Perpetual Youth*, at Fontainebleau (fig. 62). To the right of this scene, between it and *The Death of Adonis*, a chubby, naked, and smiling stucco *putto* touches his penis with his right hand, an action observed with some interest by a young girl who, with him, frames the small bas-relief of Cybele's chariot (fig. 63); this festive show of willy grabbing is in stark contrast with the tragic scene that neighbors it. Farther along, to the right of the fresco of Kleobis and Biton, another figure executed in stucco, a winged child seated on the monogram of King Francis I, also touches his privates. The tradition continued in Jean Cousin's large drawing of naked children playing piggyback in a landscape of theatrical ruins: one of them pisses on the calf of a carrying child who lags behind another pair to his right (fig. 64). This slightly lugubrious joke—the association between ruins and child's play—is characteristic of the spirit of Fontainebleau. In Boyvin's *Tale of Jason* (1563), engraved after the drawings of Léonard Thiry, the meeting between Jason and King Aeëtes is accompanied by two *putti* positioned just beneath the two primary characters, breaking the inner frame. Both of them urinate, one into a nearby vase and the other in the direction of yet another *putto* with his arms around a barking dog (fig. 65).[1]

As for Michelangelo, he certainly passed through Ferrara in 1529, where he saw firsthand the collection of Alfonso d'Este, including the mythological paintings by Titian, his eminent rival. In 1533, he reworked the theme of the children's bacchanal in one of the magnificent private drawings (*Ganymede*, *Tityus*, *Phaeton*) offered to his young friend Tommaso de' Cavalieri (figs. 66a–66b). The naked children are arrayed in a handful of groups, each engaged in a different set of actions: lifting a cloth over the shoulders of a man enfeebled by too much drink; sucking from the hanging teat of an aged female satyr; stirring the contents of a cauldron on a fire; carrying a suckling boar; struggling to hoist a large deer; drinking straight from the wine vat near the upper right corner, or plunging their limbs into it. Near the latter group, a squatting child holds out a cup to another who, smiling, pisses into it; the first child stretches his left index finger toward the stream, touching it as if he wanted to encircle it. Perhaps this is the same cup that another, massive child, further to the right, is about to drink from, pouring wine into it from a carafe? What does it all mean? What is the point of this esoteric hodgepodge? As in the other drawings Michelangelo made for Tommaso, everything in this bacchanal seems to be a symbol: every part of the image appeals to some higher meaning, but that higher meaning continually escapes, erases itself, remains an enigma. Rather than a lesson on sobriety, some have seen this drawing as an image of animalistic life, a lower rung on the Neoplatonic ladder:

Now, it is within the compass of these most primitive natural functions that the scenes in the Children's Bacchanal unfold: eating, drinking (and the opposite of both), nursing of babies and drunken sleep, all this enacted by beings either too young, or too little distinguished from animals, or too much deprived of their consciousness and dignity, to be fully human.[2]

Where the punishment of Tityus and Phaeton's fatal plunge "exemplify the fate of those who are incapable of controlling their sensuality and imagination, the Children's Bacchanal, which is entirely devoid of amorous tension, might thus be the image of a still lower sphere: the sphere of a purely vegetative life which is as much beneath specifically human dignity as the Mind is above specifically human limitations."[3]

Could it be that Michelangelo, by selecting some of the motifs he had seen in the canvases at Ferrara only to subvert them, took aim at Titian indirectly, reacting against his adorable *putti*, his complacent sensuality and unbridled naturalism? It's as if he was trying to exorcise all this pagan merrymaking in the name of Neoplatonism. And in the process he applied the same kind of dry humor that led him to paint himself into the flayed skin of Saint Bartholomew in *The Last Judgment*: Titian's open countryside gives way to a grotto closed off by a curtain; the young male satyr of the *Bacchus and Ariadne* becomes an aged female satyr whose breasts hang like wineskins; Michelangelo translates Titian's second satyr,

who brandished a leg torn from a young bull while the first satyr dragged the bull's head on a cord, into the seven children struggling under the weight of an entire, colossal deer; and the child pissing into the river of wine now pisses into a cup of wine from which he or another is going to drink.

Even with all this, the drawing has nothing caricatural or parodic about it. It is austere, and exceptionally detailed, the contours emphasized, luminosity patiently handled with minuscule strokes of red chalk that play against the grain of the paper. The figures are organized into five compact groups, pressed up against the foreground of the image, as the figures of *The Last Judgment* will also be some years later. The bodies of these children are heroic, well muscled, especially that of the little girl who holds up the deer's posterior. If the drawing has anything in common with the paintings at Ferrara, it's the extreme meticulousness, the seriousness of the execution, but the seriousness here is entirely different from that of Titian's paintings in the *camerino*. A hint of tragedy colors this children's bacchanal, which "investigate[s] the darker side of the bacchic mysteries, connected to the cycles of death and regeneration": [4] Hades and Dionysus are one and the same, as Heraclitus pointed out long ago. The old satyr with her massive, pendulous breasts and twisted mouth inspires pity in a spectator rather than laughter: she holds up the child that suckles her, but her head turns away from him, perhaps in disgust, and she directs her gaze instead toward another child whose bot-

tom is pressed against her half-goat thigh, on which, as Panofsky suggests with his phrase "eating, drinking (and the opposite of both)," he could very well be voiding his bowels, a counterpart to the child who pisses in the upper right corner. The central group of children, struggling to lift a deer with the head of an ass, elicits an empathetic feeling of pain and almost of terror. Only the little pisser in the upper corner manages a smile, emphasized by a dimple, a smile echoed by the slight grin of the boy in the bottom right corner whose gaze is directed down and away while his right thumb rests near his penis. But their pleasure remains theirs alone, with no chance of contagion: that seems to be the message of the sardonic profile—apparently a mask[5]—of a child wearing a bonnet at the far left who watches his neighbor tend the fire. The image in general lives up to Baudelaire's private definition of Beauty, as laid out in *Fusées*: "It is something ardent and sad, something a little vague, leaving room for conjecture." At the same time, with its infinite number of meticulous strokes, shaped, as some have said, like minuscule tears,[6] it seems like the final product of the process of sublimation through which the fifty-eight-year-old artist put to paper his passion for the young man of sixteen or seventeen (so it seems),[7] a passion Michelangelo implicitly confessed when he offered Tommaso the drawings of Ganymede and Tityus: "It would be permissible to name the things of which one makes a gift to him who receives them, but a proper sense of what is fitting prevents it being done in this letter." [8]

A dozen years earlier, Michelangelo had attached himself to a young Florentine nobleman, Gherardo Perini. A sheet of paper from that era (fig. 67) bears a number of drawings crowded together, of which the principal shows a boy, almost naked under a bizarre piece of headgear, pissing into a vase. His profile is accompanied by a note written with the paper rotated ninety degrees clockwise: "As Perino is not here, I beg you not to make me draw tonight," inscribed under a verse in Latin by Petrarch, an homage to Vaucluse (*Valle lochus chlausa toto michi nullus in orbe*). According to Tolnay, Michelangelo made these drawings "to amuse himself, probably during merry parties with friends." [9] Is the plea addressed to these merry-making friends? Why would Perini's absence keep the great man from drawing? And what pressure would have pushed one toward the other on the same sheet of paper, these words together with this image? The note and the drawing, thus associated, give the impression of a violent need, a dark shadow over the convivial gathering; they evoke the bitter verses Michelangelo wrote in criticism of his absent friend, to whom he had given a drawing of the head of a screaming man (fig. 68):

*Quinci oltre mi legò, quivi mi schiolse,*
*Per me qui piansi, e con doglia infinita*
*Da questo sasso vidi far partita*
*Colui c'a me mi tolse e non mi volse.*

[There he bound me, and here he unbound me,
Here I wept for my fate, and, with infinite grief,
From this very rock I watched him leave me,
He who took me from myself, and did not want me.][10]

This is what imbues the stream of urine in the *Children's Bacchanal* with a tortured subjectivity, and colors the lesson on Neoplatonic sublimation delivered by Michelangelo to Tommaso, and above all to himself. No doubt, we must follow Mary Garrard when she questions Panofsky's assertion that the *Bacchanal* is "entirely devoid of amorous tension": the erotic involvement of the subject and the mystery of that involvement are buried at the very heart of the image. As a catalog of the British Royal Collections put it around 1800: "The subject very obscure, but the Drawing very Capital." [11]

---

1    Patricia Simons sees these two streams of urine as symbols of vaginal and anal intercourse, respectively ("Manliness and the Visual Semiotics of Bodily Fluids in Early Modern Culture," p. 342).

2    Erwin Panofsky, "The Neoplatonic Movement and Michelangelo," in *Studies in Iconology* (New York: Harper & Row, 1962), p. 223.

3    Ibid.

4    Alexander Nagel, *Michelangelo and the Reform of Art* (Cambridge: Cambridge University Press, 2000), p. 161.

5    Françoise Viatte has confirmed to me that it is indeed a mask. Mary D. Garrard reveals that Enea Vico and Nicolas Beatrizet rendered it clearly as such in their engraved versions; see her article "Michelangelo in Love: Decoding the *Children's Bacchanal*," *Art Bulletin* 96, no. 1 (March 2014): p. 39.

6    Michael Hirst, *Michel-Ange: Dessinateur*, exh. cat. (Paris: Réunion des musées nationaux, 1989), p. 116.

7    Tommaso's age is an open question. Stephanie Buck discusses the issue in *Michelangelo's Dream*, exh. cat. (London: Courtauld Gallery, 2010), p. 76.

8    Michelangelo in a letter to Tommaso de' Cavalieri, January 1, 1533; reproduced with commentary in Marcella Marongiu, ed., *Il mito di Ganimede prima e dopo Michelangelo*, exh. cat. (Florence: Mandragora, 2002), pp. 72–73: "The final phrase is strongly allusive, hinting in coded words at the passion that tortures the artist."

9    Charles de Tolnay, *Corpus dei disegni di Michelangelo*, vol. 1, *Disegni degli esordi e della gioventù fino al 1520 circa* (Novara: Istituto geografico de Agostini, 1975), p. 72, pl. 70.

10   Michelangelo, poem G 36, "Oltre qui fu, dove 'l mie amor mi tolse." [Trans. note: The English translation is mine.]

11   Quoted in Paul Joannides, *Michelangelo and His Influence: Drawings from Windsor Castle* (Washington, DC: National Gallery of Art, 1996), p. 207.

*The place was cover'd all over with delicate firm young Breasts, fastened together in pairs, like Bowls; I took great delight in Rowling myself over 'em. And being supinely lay'd, a Fair Lady came and kneel'd down by me, and having a Vessel in her Hand, and Funel, which she put in my Mouth, telling me she would make me Drink the most delicious Liquor that ever was tasted: I open'd my Throat as wide as the Singing-Man that swallow'd a Rat instead of a Hop-Seed; and she getting up a little, Piss'd above a Winchester-Quart full in my Mouth, and made me gulp it every drop down. I started up to be Reveng'd of her, and but just gave her one Blow, and she fell all to pieces; here lay her Head, there was her Legs, in another place lay her Arms, and no two parts together, but what was more wonderful, every Member immediately after discharg'd its own function; the Legs walk'd about, the Arms struck me, the Tongue revil'd me, the mouth grinn'd at me.*

*The fear of coming to trouble, for the Death of this Woman, made me beat my Brains to bring her to Life again. For remarking every one of her Limbs did its respective Duty, I concluded they wanted nothing but placing, to recover her. Having gathered up several Parts of her, and put 'em in order, I was so charm'd with her Belly, that I could not forbear sacrificing to Venus, in hopes to expiate my former roughness to her, but as I was beginning the endearing ceremony, her Tongue, (which I had not put on as yet) cry'd out, those are not our Breasts, which made me look out for the right, which*

*having found, and put in order, her Head, and Arms, came of their own accord, and settled themselves in their Natural position. Now the Mouth Kiss'd me, and the Arms hugg'd me passionately, and all ended in melting raptures, and transporting Joyes.*

*Charles Sorel,* Histoire comique de Francion, *bk. 3 (1623)*[1]

---

1   [Trans. note: The English text is from the 1703 translation printed in London for R. Wellington.]

## Pissing Girls

It goes without saying that all these pissing youths are and must be male, certainly for physiological reasons, but above all for symbolic ones: with their little instruments, they represent virility in action and the power relations inscribed by the phallus in human civilization. In the Western classical tradition, representations of girls or women pissing are rare but remarkable, and are tied, when they appear, to an iconography of exception. Consider the figure of the standing young woman who lifts her dress to piss into a hat in front of the "indecent fountain," on the ceiling of the guardroom of the Château du Plessis-Bourré outside of Angers (1468–1473, fig. 69);[1] or the winged girl pissing into a wooden clog on one of the large ceiling coffers in the oratory of the Hôtel Jean Lallemant in Bourges, which burned down and was rebuilt around 1500. She opens her gown to make way for a wavy, thick, and straight stream, in contrast to the more or less parabolic curves that generally emerge from the penises of little boys; a bit of it drips down her right calf (fig. 70). These images are enigmas, which have most often been connected to alchemy.[2] A fifteenth-century text, falsely attributed to Nicolas Flamel, includes a child's urine as an ingredient in the manufacture of the Philosopher's Stone: "*And now we arrive at the secret of secrets. It is this: you take the urine of a child of eight, ten, or twelve years of age*, who drinks wine and leads a loose life, though he be healthy and well-disposed by nature, and you collect it in a water vessel."[3] But the text does not mention any wooden clogs, nor the child's gender, and the *pisseuse*

in the Hôtel Lallemant is the sole figure legible as female in the group of fourteen *putti* that alternate with cryptic emblems (fig. 73). The twenty-four paintings of Plessis-Bourré, like the thirty coffers of Bourges that also bring together cherubs and allegorical emblems, form a cryptic ensemble that resembles Lotto's group of wooden covers in the choir of the basilica at Bergamo (fig. 74). Here and there, so many labyrinthine fantasies whose key has been lost, perhaps intentionally. But even if these works resist interpretation, we must nevertheless keep in mind the presumable intentions of the respective artists: to create images whose surprising, heteroclite nature evokes alchemical imagery.

In the sixteenth century, representations of *pisseuses* seem to have been concentrated in the northern countries. The German painter and engraver Matthias Gerung placed a winged Melancholy, placid and enormous, in the middle of his panel *Melancholia* (1558), in a landscape whose background prominently features both a rainbow and a comet. She is surrounded by numerous groups engaged in "every possible activity of urban, rural, and military life": [4] war, religious processions, work, games, acrobatics, music, dances, dancing bears, and a brothel-cum-sauna full of naked women. At the bottom left, a woman lifts up her dress to piss on the banks of a body of water; next to her, a boy vomits, holding himself up against the trunk of a dead tree (figs. 75a–75b). None of these busy individuals pay any mind to the enormous figure of Melancholy or to the celestial forces that determine their actions.

Besides this unique example, if the rest of this century, so prodigiously productive of pissing little boys, at one time or another managed to portray a urinating woman, it was only with the proviso that she retain an allegorical aspect, mythological or animalistic. Cornelis Bos's 1543 *Triumph of Bacchus* includes a fleshy naked woman at the engraving's extreme left edge, half-fawn, with a human right leg and a goat-like left, who pisses vigorously while drinking from a wineskin held out to her by a muscular satyr, his torso girdled by a grapevine (fig. 76a). Toward the center of the image, a dead-drunk satyr is slumped over asleep on his stomach, his open asscheeks visible in a mirror held by a nearby *putto*, and one can see in the reflected image that the satyr has shat himself (fig. 76b). In this engraving, his face lies in a pool of his own vomit, but not in the painting by Van Heemskerck (c. 1536–1537), a more compact version where the fawn-woman is replaced by a man who isn't pissing (fig. 77).

Jacopo Zucchi's small-scale *The Golden Age*, painted around 1575 as a pendant to *The Silver Age*, depicts groups of naked people who dance or embrace in a fanciful landscape. Two children piss together into a river in which other children bathe: *oro* and *orina*, the color and the verb, offer an image of a social harmony with no need for laws, situated in an Eternal Spring. The Golden Age, as described in Hesiod, Tibullus, or Ovid's *Metamorphoses*, knew no violence; labor and domination were equally foreign to it. In the highly finished preparatory drawing conserved at the Getty Museum, the children are small boys

whose streams cross one another, with the stream of the leftmost boy passing in front of the face of his companion, bisecting it (fig. 78). But the pissing figure on the right in the Uffizi's painting is a little girl who, thighs spread, releases a forceful stream that separates into two streams as it falls; the boy, now crowned with a garland of leaves and flowers, lifts his little member high, so that the arc of his urine encircles the girl's head like a halo (fig. 79).[5] One might say that the little man is already assuming a stance that will enable him to both dominate and protect his mate, with a curve:[6]

$$y(x) = -\frac{1}{2}\frac{g}{v_0^2}\frac{\cos(\gamma)}{\cos^2(\beta)}[1+\tan^2(\alpha)]x^2 + \tan(\alpha)\frac{\cos(\gamma)}{\cos(\beta)}x$$

The boy's enveloping curve heralds the arrival of the Silver Age, and, with it, the rule of law, represented in that painting's central figure, a large Justice armed with a sword and scales (fig. 80).

According to a description by Vincenzo Borghini, the Golden Age had previously provided the subject for a painting by Poppi based on a drawing by Vasari, dated a few years earlier.[7] Neither Borghini's text nor Poppi's canvas made room for pissing figures, male or female: the addition was Zucchi's own innovation on the theme, or that of his patron, Cardinal Ferdinando de' Medici, the future grand duke of Tuscany.

We have to fast-forward a half century and travel all the way to the Netherlands to find a couple urinating without fuss, in Rembrandt's etchings of a pissing man

and woman (figs. 81a–81b). No more allegorical children, levity, cryptic symbols, curves, or allusive masculinity; just two peasants, male and female, who piss straight ahead, the woman turning around to reassure herself that no one is watching. What could Rembrandt have intended with this last detail, when he places directly before our eyes the same exhibition of urine (and shit) that the woman, looking about uneasily, hopes to conceal? As examples of a genre then in vogue in the Netherlands, these small etchings, about three inches high, simultaneously demonstrate high virtuosity and a contempt for custom. In their rusticity, an aspect Callot had already captured in one of his *Caprices* (fig. 82), these two figures converge with the pissing cows of Paulus Potter or Nicolaes Berchem (Claudel, speaking of Jordaens, described his work as "a human cowshed," before eventually coming around). But they have the kind of dignity that unaffected men and women share with animals: nothing like this would be seen again, at least not in the West,[8] before Gauguin's Tahitian woman (*Te Poipoi*, 1892, see fig. 109), where it is impossible to tell if she is urinating, or bathing herself, or both. The young Rembrandt's target was the allegorical humanism then in fashion in Italy, as he confirmed some years later with his *Ganymede*, now in the Staatliche Kunstsammlungen Dresden: no longer a graceful Trojan adolescent more or less consenting to his own abduction, but a big baby with a fleshy ass who cries and pisses in terror, clinging in vain to the cherries he holds in his left hand (fig. 85).

In the decades that followed, up to the middle of the twentieth century, Rembrandt's *pisseuse* was caught in a closed circuit of voyeurism. Uncountable knickknacks, paintings, drawings, and photographs married amusement and erotic excitation for the male gaze (figs. 86–88),[9] the *geloiastos* from *Poliphilus* passed down to the present, thanks to the pornographic sites that proliferate in even greater numbers on the Internet. Lequeu's *pisseuse* listens to herself only so that our male gaze can be simultaneously aroused and amused at her expense (fig. 89).[10]

This tradition remains one of strictly private use: when the banker and collector Randon de Boisset commissioned or purchased three small erotic canvases from Boucher, including a *pisseuse*, he had them covered with sanitized doubles (a dog standing on its hind legs replaces the chamber pot the woman had previously used to relieve herself, figs. 90a–90c), in keeping with a common practice that continued up to Courbet's *Origin of the World*, a practice we also find in Japan.[11] But Boucher took care to leave in a young man, visible through a dark windowpane, observing the scene: as if he were a projection of the real spectator. The artist lets us infer the voyeur's reaction, both in the image and out of it; but the Japanese tradition of *shunga*—images of spring—is more straightforward, and a few decades after Boucher, one can contemplate in a woodblock print by Utamaro not only a woman preparing to relieve herself but her voyeur, a young man with his ass in the air, masturbating furiously (fig. 92).[12]

The visible presence of the gaze returns in the chamber pots known as *vases de mariée* (brides' vases), at the bottom of which a wide-open, painted eye soaks up the sight of an invigorating shower (fig. 93);[13] it was also taken up by Picasso in his late period, in an aquatint that connects the *pisseuse* and Susanna surprised by the elders (fig. 94).

The twentieth century brought legitimacy to the theme of the pissing woman, at the same time robbing it of its erotic charge. The little pissing nude scribbled by Klee in 1908, one of a series of nudes in ink, has a clearly satirical tone (fig. 95).[14] However, it was only in the second half of the century that *pisseuses* took on greater importance, with the large *Pisseuse* painted in 1965 by Picasso (fig. 96), which followed on the heels of Dubuffet's *Pisseurs* (1961–1962) while also drawing on Rembrandt's etching *Pissing Woman* and his painting entitled *A Woman Bathing in a Stream*. More recently, some artists have attempted to bend the theme back toward pornography, now a source of motifs for art of all kinds. Modifying traditional (generally anonymous) pornographic imagery in order to confer on it the qualities of an artistic nude, the photographs of Gilles Berquet (fig. 97), Claude Fauville (fig. 98), and Laurent Benaïm grace their black-and-white *pisseuses* with a distinguished pedigree.[15] At the same time, female and/or feminist artists also took up the theme. In 1995, Sophy Rickett, in an elegant black-and-white series, photographed herself pissing standing up in tranquil London exteriors (fig. 99);[16] between 2001

and 2012, the Basque performance artist Itziar Okariz filmed and exhibited a series of pissing actions, *Mear en espacios públicos o privados* (fig. 100); [17] in 1992, Kiki Smith produced *Pee Body*, a wax sculpture of a naked, squatting woman who pisses glass pearls (fig. 101); and in 1996–1997, Marlene Dumas paid homage to Rembrandt's *pisseuse* in a number of ink washes of pissing women (fig. 102).[18] As for male artists, Robert Smithson proposed a project entitled *Urination Map* for a place named Loveladies, New Jersey: "he planned to urinate in six different locations which, together, would form on the ground an image of the constellation Hydra." [19] But the context has significantly changed; now, urine seems to be used for provocation or to stake out a position. Or it smacks of deviance: Dutchman Leo, the inspiration for Andres Serrano's Cibachrome print *Leo's Fantasy*, confessed to the artist's assistant that the sight of a woman pissing into a man's mouth aroused him. Serrano, who was at work on his series *History of Sex*, replied: "Why not? We do requests" [20] (see fig. 114).

---

1    Brought to my attention by Andrew Chen. See Eugène Canseliet, *Deux logis alchimiques: En marge de la science et de l'histoire*, 3rd ed. (Paris: Éditions Pauvert, 1979), pp. 218–225, and Michel Bulteau, *Le Plessis-Bourré: Alchimie et mystères* (Paris: Livre-Essor, 1983), pp. 86–89.

2    Michel Bulteau, *L'Hôtel Lallemant à Bourges* (Paris: Garancière, 1984); Jean-Jacques Mathé, *Le Plafond alchimique de l'Hôtel Lallemant à Bourges: Commentaire symbolique et hermétique des 30 caissons sculptés reproduits intégralement pour la première fois* (Braine-le-Comte: Éditions du Baucens, 1976).

3     Christophorus Parisiensis, *Apertorio alfabetale* (1466); French trans. *Le grand esclairsissement de la pierre philosophale* (1628; repr., Paris: Arma Artis, 1976), p. 37. On the fictive attribution to Flamel, see the edition of his alchemical writings edited by Didier Kahn, *Écrits alchimiques de Nicolas Flamel* (Paris: Les Belles Lettres, 1993), p. 113. See also the "warm urine of a child," *pueri calidam aquam*, in Emblem XL of Michael Maier's *Atalanta fugiens* (1618), the *Tractatus de urina* attributed to Johannes Isaac Hollandus (sixteenth or seventeenth century), the *Speculum veritatis* by George Starkey (seventeenth century, fig. 71), the *Cabala mineralis* attributed to Simeon ben Cantara (seventeenth century, figs. 72a–72b), etc.

4     Raymond Klibansky, Erwin Panofsky, and Fritz Saxl, *Saturn and Melancholy* (London: Thomas Nelson, 1964), p. 381. With gratitude to Patrick Javault.

5     *Masterpieces of the J. Paul Getty Museum: Drawings* (Los Angeles: J. Paul Getty Museum, 1997), p. 30; *Miroir du temps: Chefs-d'œuvre des musées de Florence*, exh. cat. (Rouen: Musée des Beaux-Arts, 2006), pp. 134–135. The pissers in *The Golden Age* are reproduced in Eduard Fuchs, *Illustrierte Sittengeschichte vom Mittelalter bis zur Gegenwart*, vol. 1, bk. 2, *Renaissance* (Munich: Albert Langen, 1909), p. 172, with an attribution to "Frederigo Zucheri," corrected by David Monteau.

6     This equation for the stream's curve was kindly provided by David Monteau: "*y*' and *x*' are the coordinates of the stream's plane, *g* is the gravitational constant, $v_0$ is the initial velocity of the stream, and α the initial angle of inclination. The classic equation for the curve would then be:

$$y'(x') = -\frac{1}{2}\frac{g}{v_0^2}[1 + \tan^2(\alpha)]x'^2 + \tan(\alpha)x'$$

But this curve must be projected onto the plane of the canvas, which is perspectival and seen from above.

"*x* and *y* are the coordinates determining the plane of the canvas, β the perspectival angle on the stream (the angle of horizontal rotation between the plane of the canvas and the plane of the stream), so that $x = x' \cos(\beta)$, and γ is the angle of the point of view (the plane of the canvas's angle of inclination with respect to the vertical axis), so that $y = y' \cos(\gamma)$."

Of course, this equation does not take into account "the density of the child's urine, nor the atmospheric density in such a clime," two variables whose values, for the time being, remain unknown.

7     Poppi's canvas is in the collection of the National Gallery of Scotland, and the drawing by Vasari is in the Louvre; see Alessandra Giovannetti, *Francesco Morandini detto il Poppi* (Florence: Edifir, 1995), p. 76; p. 117, fig. 3. Borghini's text is reproduced in Ugo Scoti-Bertinelli, *Giorgio Vasari, scrittore* (Pisa: Nistri, 1905), pp. 229–230.

8   One plate of Utagawa Kuniyoshi's erotic album *Ôeyama* (*Tale of the Drunken Demon*, 1831, fig. 83) is a street scene in which a woman and a man piss Prussian blue; a dog sniffs at the woman, and the man's stream takes a contorted form often found in Japanese art, up to the jet of sperm in Takashi Murakami's *My Lonesome Cowboy* (1998, fig. 84). My gratitude to David Monteau (who also brought to my attention the Utamaro print mentioned later in this chapter), and also to Ricard Bru i Turull.

9   See Alexandre Dupouy, *Joyeux Enfer: Photographes pornographiques 1850–1930* (Paris: La Musardine, 2014), pp. 66–73.

10  Philippe Duboÿ, *Jean Jacques Lequeu: Une énigme* (Paris: Hazan, 1987), p. 293.

11  François Boucher, *La femme qui pisse ou L'Œil indiscret*, covered by *The Learned Dog*; Nadeije Laneyrie-Dagen and Georges Vigarello, eds., *La toilette: Naissance de l'intime*, exh. cat. (Paris: Hazan, 2015), pp. 108–115. In Utagawa Kunisada's album *Hyakki yagyô* (*Night Parade with One Hundred Demons*, 1825, figs. 91a–91b), one part of an image, depicting a door, folds back to reveal a woman pissing in a bathroom; *Shunga: Images de printemps*, exh. cat. (Paris: Tanakaya, 2003), pls. 27–28.

12  *Ehon takara-kura*, 1800; reproduced in Ofer Shagan, *Japanese Erotic Art* (London: Thames & Hudson, 2013), p. 189, fig. 36.

13  See Anatole Jakovsky, *Éros du dimanche* (Paris: Éditions Pauvert, 1964), pp. 181, 230. In Provence, the eye sometimes speaks: *Aviso, couquinet, que iéu te vese.*

14  Pointed out by Angela Lampe. See Angela Lampe, ed., *Paul Klee: L'ironie à l'œuvre*, exh. cat. (Paris: Centre Pompidou, 2016).

15  My gratitude to Alain Kahn-Sriber, as well as to Alexandre Dupouy.

16  With thanks to Emma Hall.

17  With thanks to Carel Blotkamp.

18  *Marlene Dumas*, exh. cat. (Paris: Centre Pompidou, 2001), pp. 14–15, 90, 91 (text by Jonas Storsve).

19  Gilles A. Tiberghien, "La Poésie et les arts dans les années soixante aux États-Unis," forthcoming in *Cahiers du Musée national d'art moderne*.

20  *A History of Andres Serrano: A History of Sex*, exh. cat. (Groninger: Groninger Museum, 1997), p. 110.

# Modernities

With the development of genre painting around 1600, more and more adults began to piss in images. In fancy dress, or in everyday clothes, solo or in groups, in the North as in the South, in drawing as in painting, they were introduced into representations of drinking parties, like Willem Buytewech's *Merry Company* (c. 1622–1624, fig. 103a), a brothel scene in which a well-to-do man pisses into a chamber pot (a detail covered over by conservators at Berlin's Staatliche Museen at the beginning of the twentieth century, fig. 103b); they pop up in various series of drawings of ordinary men who piss into the air, or against a wall, or even from their saddles, a set of motifs abundantly represented in the Netherlands (Willem Basse, fig. 104; the half brothers ter Borch, fig. 105), but which also appear in Bologna (c. 1595–1600, fig. 106), Florence (Callot, c. 1620), and Rome (Mola and Simonelli drew each other in the act of pissing in the gardens of the Villa Pamphili, 1649, fig. 107).[1] At the end of the eighteenth century, the theme was reprised in Thomas Bewick's *British Birds*, whose chapter on the merlin (*Falco Æsalon*) closes with a vignette of a man who pisses toward his own shadow, cast onto a ruined wall surrounded by shrubs (fig. 108).[2]

While these images exhibit a more convivial approach to excretion than the one currently in fashion, they also respect the decorum of classical art, consigning the adult pisser to genre painting and private drawings. The stature of these kinds of representations changed only at the end of the nineteenth century. In 1892, in *Te Poipoi* (*The Morning*), Gauguin's Tahitian woman, squatting in

the great outdoors, offers us a modern-primitive vision of the Golden Age (fig. 109), at the very moment the introduction of new public bathroom kiosks made urination and defecation into private acts. As a result of that transformation, illustrations of these acts were charged with a new aggression. In 1887, Ensor etched a man in a hat, seen from behind, pissing onto a wall marked with juvenile graffiti and the inscription "ENSOR EST UN FOU" (Ensor is a madman, fig. 110). Ensor had drawn inspiration from Callot's *Pisseur*, a drawing reproduced on page 29 of Marius Vachon's *Jacques Callot*, published the previous year. By adding the inscription and graffiti, Ensor simultaneously owned up to and pissed on the accusations of madness and juvenile stupidity that dogged both him and his work.

The twentieth and twenty-first centuries were soon to offer a reinvigorated and brutal vision of urination, a barrage of urinary provocations, each one more confrontational than the last, like a storm gathering strength before flattening everything in its path. In 2013, Paul McCarthy exhibited *WS*, an enormous seven-hour-long video installation piece in New York's Armory. It was a subversive take on Disney's *Snow White* ("a vulgar, graphic, pornographic, sexual nightmare. I'm immediately nauseous just remembering the shit-splattered walls and violent sexual acts involving urine and feces [which wasn't even the worst of it]");[3] he had previously prepared and exhibited a number of drawings of Snow White in every state imaginable, Snow White getting

fucked, Snow White pissing while Disney rabbits and fawns look on, Snow White and Prince Charming pissing side by side, two smiling but absolutely charmless figures, with an air of lukewarm aggression (figs. 111a–111b).

The Viennese Actionists had pioneered these new developments in excremental art: in Kurt Kren's short film *20. September* (1967), Günter Brus is shown pissing, drinking, shitting, and eating—Rubens's cycle, but with an aggressive ugliness that indexes just how much excrement had become an object of disgust over the preceding centuries, the same period in which the act of excretion itself became increasingly private (fig. 112). In his action for *Kunst und Revolution* (University of Vienna, 1968), Brus stripped off his clothing except for his socks, climbed onto a chair, slashed his chest and thigh with a razor, pissed in front of the audience, drank his piss, shat and smeared himself with his own shit, then lay down and masturbated while singing the Austrian national anthem, all while Otto Muehl whipped a student wrapped in newspaper. Slightly later, in Munich, Muehl also pissed in front of the audience (*Piss Action*, fig. 113). Any potential innocence, grace, or warmth have disappeared in favor of pure scandal. These actions call to mind the "urine dance" of the Zuni people of New Mexico, in which they drink and eat their own excretions. Captain John G. Bourke observed the dance in 1881, describing it as abject and grotesque; [4] but while a ceremony like the "urine dance" was ritualized and private, the public actions of Muehl, Brus, and company brought down police repression and

legal sanctions. Brus was condemned to six months of prison and was obliged to flee to Berlin, while Muehl, for his part, had to leave Germany.

Taking up a theme common in s&m pornography and erotic literature (there's a lot of pissing in Bataille's *Story of the Eye*),[5] images of "golden showers," male and female, are now widely disseminated by specialized Internet sites;[6] the stream of piss, cascading onto a body or into a mouth, is a delicious humiliation. Set in a location that recalls a basement or a gloomy club with scattered detritus and graffiti, Robert Mapplethorpe's *Jim and Tom, Sausalito* (1977) shows a man stripped to the waist wearing a leather hood, a leather collar, leather pants and boots, holding his penis in a leather-gloved hand as he pisses into the wide-open mouth of a bearded man kneeling in front of him; behind the pisser, a ladder and its shadow lend the scene a dramatic air. Two other photos follow this one in a sequence, and another shows Jim, alone, clinging to the ladder, his body facing forward and his hooded features in profile. As is always the case with Mapplethorpe, the motif is staged, suffused with his characteristic air of trashy sophistication.

In Andres Serrano's Cibachrome print *Leo's Fantasy* (1996), one of the episodes in his *History of Sex*, a woman in a short black corset, her thighs spread, looses a stream of urine into the mouth of a blond man, holding his head up by the hair (fig. 114). The scene is handled with a clinical distance, and the desire of the man who quenches his thirst, if, indeed, there was desire, is entirely absent from

the final image. Was Leo satisfied with his photo? Intensity and distance are as bound together as the headless woman and the man without genitals. Nine years earlier, Serrano had caused an unprecedented scandal, one that still provokes strong reactions today, with *Piss Christ*, a photo of a crucifix immersed in a red and yellow urinary glow, creating around the image of the Messiah a halo dotted with little bubbles of air (fig. 115): a fantasy already made flesh in Norifumi Suzuki's 1974 film *School of the Holy Beast*, in which a pregnant nun, tortured by being forced to drink large quantities of salt water, dies while pissing on a crucifix.[7] Serrano's motif was reprised in animated form in the title sequence of Nigel Wingrove's 1999 film, *Sacred Flesh*.

These works from our own time are charged with nostalgia for a lost innocence, but an innocence lost complacently, as in Baudelaire's "Perte d'Auréole." Urine is no longer the *acqua santa* of the baby, which could appropriately wind up in the *acquasantiero*, the holy-water font; excessively aestheticized, it becomes an image of profanation, of depravity, of the evil that does one good, the symptom of a decline running inevitably to ruin, of an era trying to shed its old skin. One is reminded of Riegl's comments at the beginning of *Late Roman Art Industry*:

> It is known that the ancients were careful to avoid anything which reminded them of calamities and adversities of any kind ... when they gave names to persons, localities, and such.... But now listen to the

names of late Romans and early Christians: Foedulus, Maliciosus, Pecus, Projectus, Stercus, Stercorius.... Now, these writers avoid exactly what pleased classical mankind, and seem to have chosen with pleasure the opposite of what was avoided earlier. While previously one wanted to hear about victory and conquest, so now one wanted disgrace and atrocity. Admittedly, these are extremes which were seldom reached, but they indicate precisely and clearly the direction taken by the new "unclassical" way of feeling in the late Roman world.[8]

This late-Roman punk, almost contemporaneous with the bacchic-urinary sarcophagi of the end of the third century, has contemporary echoes in the modern cultural sensibility of *no future*: we put human skulls on our keychains and T-shirts.

One thing that has changed significantly from then to now is the age and status of the pissers. The innocent, impish naked toddlers and the clothed adults who relieve themselves without ulterior motive have given way to images in which sexual connotations return to the surface. In the twentieth century, the three sailors in a watercolor by Charles Demuth, the excellent, precisionist, homosexual American painter and friend of Duchamp, show off their immodestly sized cocks in the course of a "pissing contest"; two of them, holding hands, gaze at each other and aim their streams of piss toward the viewer (fig. 116).[9] Has the world evolved? Today, an image

like this one, not suitable for the mass market in 1930, would draw barely more than a titillated but disinterested glance. More recently, Sadao Hasegawa's multicolored homosexual orgy fantasy *Gon Gu Edo II* (*Joyfully Seeking the Impure Land II*, 1981: green and white double penetration with biting, a pink penis pissing into the mouth of a muscled and bound orange victim with an explosive, enormous erection) can make a viewer laugh and/or give him a hard-on (fig. 117). But, for now, the unrestrained expression of adult fantasies stops short of including pedophilia: a photograph that publicly presented the image of a child pissing the way the theme was handled in the Renaissance would doubtless attract the attention of the vice squad. The Actionist Otto Muehl was sentenced in 1991 to a hard seven years for affronts to public decency, violation of drug laws, and incitement of the corruption of minors. And when an artist of the twenty-first century chooses to portray pissing adolescents—Norbert Bisky, *The Artist at Work* (2005, fig. 118); Marwane Pallas, *Unload* (2013, fig. 119)[10]—an element of fleshy provocation in the Boy Scout ambiance inevitably reminds us that the age of innocence is now little more than a flirtatious pose.

---

1   The majority of these examples were provided by Guillaume Cassegrain, who reproduced the Bolognese drawing in *La Coulure* (Paris: Hazan, 2015), p. 203.

2   Pointed out by Henri Zerner.

3     Andrea DelBene, "Paul McCarthy's repulsive rendition of Snow White and the 7 Dwarves," *Lost at E Minor*, August 22, 2013, http://www.lostate minor.com/2013/08/22/paul-mccarthys-repulsive-rendition-of-snow-white-and-the-7-dwarves-at-nycs-park-avenue-armory/. Entry was prohibited to visitors under the age of seventeen. My thanks to Patrick Javault.

4     John G. Bourke, *Scatalogic Rites of All Nations* (Washington, DC: W. H. Lowdermilk, 1891), pp. 4–10 (available online at https://archive.org/details/101486300.nlm.nih.gov).

5     For other examples, see Serge Koster, *Pluie d'or: Pour une théorie liquide du plaisir* (Paris: La Musardine, 2001).

6     One of hundreds of examples: "A young guy is in the decrepit public bathroom with some friends who takes their cock out and piss straight into his mouth. A little amateur video that proves young people get off on this sort of thing too ;)," G**s***b**'s blog.

7     Brought to my attention by Jean Louis Schefer.

8     Alois Riegl, *Late Roman Art Industry* (1901), trans. Rolf Winkes (Rome: Giorgio Bretschneider, 1985), p. 13. See also Edmond Le Blant, "Recherches sur quelques noms bizarres adoptés par les premiers chrétiens," *Revue archéologique* (July 1864): pp. 5, 9nn7–8.

9     Brought to my attention by Patrick Javault. See Jonathan Weinberg, *Speaking for Vice: Homosexuality in the Art of Charles Demuth, Marsden Hartley, and the First American Avant-Garde* (New Haven, Connecticut: Yale University Press, 1993), pp. 106, 108.

10     Brought to my attention by Alberto Sorbelli.

# Ambivalences

Leo Steinberg and Marilyn Lavin have both shed light on certain facts that the decline of organized religion has somewhat obscured. Christ's penis, exhibited and manipulated by him or his companions, usually holy women, is the surest evidence of his incarnation; and the water cast by the little pissers who reside in the Duomo is charged with the divine fertility of the Virgin.[1] With its theology, religion sanctifies the genitals of the male child and what comes out of them.

Could it be so simple? These images present us with a singular mix of innocence and indecency. In general, these children seem to know what they're doing, but they do it with infinite candor. They know so well what they're doing that Rubens, paraphrasing Titian's *Worship of Venus*, changed the sex of some of the figures, in particular that of the very effeminate boy with lifted arms at whom Cupid aims his bow. "In Titian's image love is between male Cupids. Rejecting this platonizing infantile eroticism, Rubens heterosexualizes the games."[2]

In the same way that the children in bacchic scenes manage to intoxicate themselves in advance, proleptically, merely by eating wine grapes, the urinary pastimes of these little sprites turn out to be the decent, amusing equivalent of the erotic games played by adults. The two are rarely brought together, as they were in Lotto; but in his painting on copper entitled *Venus and Mars* (c. 1600), Carlo Saraceni installed a group of five little cupids in a grandiose architectural space, at the feet of the eponymous gods who lie naked on a bed, kissing, with their

legs interlaced; one cupid emerges from underneath the sheet, another seems to be inspecting the cleanliness of the linens, and three others busy themselves near Mars's armor, scattered on the floor; the oldest cupid, the only one provided with wings, pisses onto the helmet where he rests his foot, admiring himself in the mirror of the god's shield, his hand stretched out toward his own reflection (fig. 120).[3]

What was he reaching out for in the image projected back to him in Mars's armor? The evanescent instant when juvenile urine will give way to martial sperm? A drawing by Annibale Carracci or a member of his circle draws the viewer's attention to the moment of this transmutation: an adolescent lifts his short tunic and pisses toward the viewer, projecting his pelvis out in front of his plump body like the pissing Hercules or the Manneken-Pis, and looking down at his own urinary stream (fig. 121).[4] His social status is unclear. He appears in a series of engravings by Simon Guillain of Bolognese petit bourgeois occupations, thus associated with the peasantry, not with pastoral. He has neither the maturity nor the clothing one would expect in an image of a peasant relieving himself, but he is also past the age of innocence typical of Renaissance *putti*. In Carracci's drawing, this ambivalence may be encoded in the *pentimento* around the urinating organ, split in two before our eyes.

The male child's urine has a double nature, religious and erotic, holy water and sperm. Holy water, with its admix-

ture of salt, is symbolically related to urine, and in Italy, it is still customary, even today, to call an infant's intemperate pee *acqua santa* (fig. 122).

This connection reappears in various societies across the globe. Not only do "Christian and other rites of baptism symbolize the bestowment of a vital fluid (semen or urine) on the initiate," but also "the holy water there used is a lineal descendent of urine, the use of which it gradually displaced," as the psychoanalyst Ernest Jones puts it.[5] Jones and Havelock Ellis remind us, following on Peter Kolb (1719), that among the Hottentot the priest customarily urinated on the couple during the marriage ceremony, and the young groom cut himself so that the stream of urine might enter him; for the Inuits, the bladder is the principal seat of the soul; in New Guinea, "in initiation ceremonies, the chief stands over the youth and urinates in his mouth; having passed this final test the youth becomes eligible as a warrior."[6] Bunjil, the eagle-god of the aborigines of Victoria, in southeast Australia, created the ocean by pissing on the Earth for days; in the Kodiak Archipelago in Alaska, the first woman gave birth to the sea by urinating; among the indigenous peoples of Kamchatka and the Eskimo, rain is the urine of a god.[7] Ellis, himself a urophile (and eugenicist), summarized urinary symbolism in broad strokes:

> Pure water and urine, both alike derivatives from the ancient salt ocean which was the remote cradle of our primitive organic life, have reciprocally heightened

each other's potent qualities. The more primitive man frankly accepts the sacredness of urine, for it is more personal and organic, more richly various in its constitution, and he dimly realizes, perhaps, that it is more approximate to the original ocean. The less primitive man, acquiring a new disgust for the physiologically natural, and at the same time developing a new symbolic conception of purity, tends to transfer all the qualities of urine to pure water. In Christendom this is so even today; Protestant and Catholic alike symbolize the purification and regeneration which every member of the Church must undergo in the sacred rite of Baptism by water.[8]

This transmutation of urine into water is marvelously illustrated by Dürer's phallic faucet, placed just under his own fly in *The Men's Bath* (fig. 123).

Nothing should be taken more seriously than laughter and disgust. Disgust for urine is relatively modern, but the association between laughter and urine seems to date from time immemorial. When he witnessed the "urine dance" of the Zunis, Captain Bourke was horrified not only by the copious ingestion of human urine by "the filthy brutes," but also by the grotesque costumes, the parody versions of Catholicism, the mockery of whatever whites happened to be present "to the uncontrolled merriment of the red-skinned listeners."[9] Bunjil's inexhaustible piss, drowning the indigenous people who have earned his disfavor and thereby creating the ocean,[10]

has something Rabelaisian to it, recalling the episode where the young Gargantua, to "give wine" to the Parisians, stands on the towers of Notre-Dame and pisses on 260,418 of them, not counting women and small children: "we're washed in sport," the sodden surviving citizens remark, "truly a sport to laugh at—in French, *par rys*—for which that city hath been ever since called Paris" (1.17) (fig. 124).

(Having flipped through the edition of Rabelais illustrated by Jules Garnier the night before, Freud dreamed that he was cleaning the excrement-encrusted seat of a country toilet by urinating on it: in the analysis, he evokes Hercules flushing out the Augean stables [that's me, Freud says], Gulliver putting out a fire in Lilliput [fig. 125], and Gargantua, Master Rabelais's giant, "der Übermensch bei meister Rabelais," who avenges himself on the gawking Parisians who sparked his ire ["daß ich der Übermensch bin," the superman, that's me]: "The fact that all the feces disappeared so quickly under the stream recalled the motto: *Afflavit et dissipati sunt*, which I intended one day to put at the head of a chapter upon the therapy of hysteria." [11] The experience of omnipotence washed away any sense of disgust: a giant's urine drowns the obscenities of the little world.)

Classic farce didn't turn its nose up at piss, drunk by the charlatan in young Molière's *The Flying Doctor*, or, in Scarron's *Don Japhet d'Arménie*, dumped by a governess onto the head of a serenader:

A GOVERNESS
  The night is perfectly dark,
Look out below,

DON JAPHET
  Look out below! Good God! I'm rank,
This last stroke of fate is a sinister omen:
Oh, thou bitch Governess, or servant, or Demon,
Who've completely bepiss'd me, miserable peasant,
Casket of living bones where Satan's the tenant,
Governess of Hell, thou thick-farded crone,
With borrowed teeth, bewigg'd, and a face like
  a stone!

A GOVERNESS
Look out below,

DON JAPHET
  The she-devil's doubled the dosage!
Execrable Ape, if it were a tincture of roses
I'd bear it in spite of the season's cruel rime;
But head-to-toe drenched in your putrid slime,
When I stood awaiting the return of my Darling,
Tainted like this, how *could* I come calling?
...
Cursèd be love, and balconies damned, all those
That, raining down urine, bespatter our clothes:
How now, the vocation of love is rough work! [12]

Dating to roughly the same period, a red chalk drawing by Pierre Brebiette shows two little cupids perched on a tree, pissing and shitting on a nymph and satyr asleep in a drunken stupor, while two other cupids, locked in an embrace, look on with amusement (fig. 128).[13]

Contamination produced by a flood of excrement involves derision and abasement on the one hand, disgust and humiliation on the other. But like all disgust, this too is the result of a long historical process of repression, a psychic prohibition whose infringement—the return of a desire or taste for piss—is henceforth considered a species of perversion, which is to say, the result of psychic regression. The process of repression that produced a general disgust for piss gradually abolished the myriad prior uses for urine, including religious, practical, magical, and medicinal applications. Where could one find in the field of modern chemistry a deluge of medicinal benefits as impressive as the litany devoted to urine in Pliny's first-century *Natural History*, in a passage that builds on Dioscorides's *De materia medica*?

> Our authorities attribute to urine also great power, not only natural but supernatural; they divide it into kinds, using even that of eunuchs to counteract the sorcery that prevents fertility. But of the properties it would be proper to speak of I may mention the following:—the urine of children not yet arrived at puberty is used to counteract the spittle of the ptyas, an asp so called because it spits venom into men's eyes;

for albugo, dimness, scars, argema, and affections of the eyelids; with flour of vetch for burns; and for pus or worms in the ear if boiled down to one half with a headed leek in new earthenware. Its steam too is an emmenagogue. Salpe would foment the eyes with urine to strengthen them, and would apply it for two hours at a time to sun-burn, adding the white of an egg, by preference that of an ostrich. Urine also takes out ink blots. Men's urine relieves gout, as is shown by the testimony of fullers, who for that reason never, they say, suffer from this malady. Old urine is added to the ash of burnt oyster-shells to treat rashes on the bodies of babies, and for all running ulcers. Pitted sores, burns, affections of the anus, chaps, and scorpion stings, are treated by applications of urine. The most celebrated midwives have declared that no other lotion is better treatment for irritation of the skin, and with soda added for sores on the head, dandruff, and spreading ulcers, especially on the genitals. Each person's own urine, if it be proper for me to say so, does him the most good, if a dog-bite is immediately bathed in it, if it is applied on a sponge or wool to the quills of an urchin that are sticking in the flesh, or if ash kneaded with it is used to treat the bite of a mad dog, or a serpent's bite. Moreover, for scolopendra bite a wonderful remedy is said to be for the wounded person to touch the top of his head with a drop of his own urine, when his wound is at once healed.[14]

Following this passage are remarks on the semiology of urine according to its color and texture, and on other superstitions associated with different manners of pissing.

It may not be impossible to find here a partial solution to the crises of health, food scarcity, and energy that overwhelm us and threaten the entire planet. Contemporary researchers have taken a renewed interest in the medicinal, agricultural, and technological powers of this inexhaustible resource, and perhaps we will soon see centenarians restored to youth by the regular ingestion of their own urine, food sources purified by its deployment as fertilizer, and machines powered by reprocessed piss. With an eye to potential developments like these, China, where eggs are still cooked in the urine of young boys, comes to seem less inhibited than the West, better positioned to take advantage of its secular traditions.[15] Isn't it true that the future sometimes turns toward surviving remnants of the past? Ancient urinary customs may have survived across the centuries here and there, in parallel with disgust for piss and its association with abasement. For instance, they may have been handed down from antiquity to the present in the day-to-day work practices of printers, fullers, tanners, painters, tinters, farmers, and apothecaries. In 1888, Captain Henri Jouan wrote to Captain Bourke from Cherbourg: "In 1847, I was then twenty-six years old, once an old woman (in Cherbourg) came to me with a washing-pan, and asked me to piss into it, as the urine of a stout, healthy young man was required to wash the bosoms of a young woman who was just

delivered of a child." [16] Bourke mentions the use of urine as a toothpaste and mouthwash among the Celtiberians, a use to which it is still put today by some modern Spaniards.[17] In *Cupid Pissing*, a satirical etching by Joachim von Sandrart (1640), an old woman in glasses, doubtless a witch, collects the urine of a naked cupid in a chamber pot (fig. 130). And Jean Louis Schefer brought to my attention a small neoclassical box decorated with a naked cupid pissing on two hearts in flames, a reinterpretation of the Hottentot marriage ceremony in the sentimental style of the period (fig. 131). Freud, referring in 1932 to the double function of the penis, erotic and excretory, noted that "there are those to whom this association is an annoyance." While he insists the two tasks delegated to the organ are mutually incompatible, "as incompatible as fire and water," Freud nevertheless thought he could affirm that "man quenches his own fire with his own water." [18]

1    Leo Steinberg, *The Sexuality of Christ in Renaissance Art and in Modern Oblivion* (London: Faber, 1983); Lavin, "Art of the Misbegotten: Physicality and the Divine in Renaissance Images," pp. 204–207.

2    Rosand, "An Arc of Flame," p. 87.

3    Beverly Louise Brown, ed., *The Genius of Rome 1592–1623*, exh. cat. (London: Royal Academy of Arts, 2001), p. 198.

4    Pointed out to me by Guillaume Cassegrain.

5    Ernest Jones, "The Symbolic Significance of Salt in Folklore and Superstition," in *Essays in Applied Psychoanalysis*, vol. 2, *Essays in Folklore, Anthropology and Religion* (London: The Hogarth Press, 1951), p. 70.

6   Havelock Ellis, "Undinism," in *Studies in the Psychology of Sex*, vol. 2 (London: Heinemann Books, 1936), p. 386.

7   Bourke, *Scatalogic Rites of All Nations*, pp. 266–271.

8   Ellis, "Undinism," p. 382.

9   Bourke, *Scatalogic Rites of All Nations*, p. 5.

10  Robert Brough Smyth, *The Aborigines of Victoria*, vol. 1 (Melbourne and London: J. Ferres, 1878), p. 429.

11  Sigmund Freud, *The Standard Edition of the Complete Psychological Works of Sigmund Freud*, trans. James Strachey, vol. 4, *1900: The Interpretation of Dreams (First Part)* (London: The Hogarth Press, 1953), p. 468. Freud had previously mentioned this Latin motto celebrating the English victory over the invincible Spanish Armada on p. 212. In both instances, his citation of the motto elides "Jehovah," the subject of *afflavit*. In pl. 16 (in color) of *Rabelais et l'œuvre de Jules Garnier*, vol. 1 (Paris: E. Bernard, 1897), Gargantua's flood of urine (fig. 126) is more academic but also more abundant than in Gustave Doré's representation. In chap. 36, Gargantua's mare pisses another flood, and, like his father, Pantagruel drowns his enemies in it (1.28). See Jeff Persels, "Taking the Piss out of Pantagruel: Urine and Micturition in Rabelais," *Yale French Studies*, no. 110 (2006): pp. 137–151. In 1929, Freud returned to the theme of Gargantua and Gulliver, these "modern giants" (Sigmund Freud, *Civilization and Its Discontents*, trans. James Strachey [New York: W. W. Norton, 1989], p. 42n4).

12  Paul Scarron, *Don Japhet d'Arménie* (1653), scene 5; quoted by Dominique Laporte in *Histoire de la merde (prologue)* (Paris: Bourgois, 1978), pp. 49–50. See also Molière, *L'Étourdi* (1653), scenes 3, 9, and the images engraved or painted by Otto Vaenius (1607) and Reyer Jacobsz van Blommendael (c. 1655, fig. 127) showing Xanthippe pouring her chamber pot over Socrates's head, based on the account by Diogenes Laertius. [Trans. note: The above translation of Scarron is mine. The original French text is as follows:

UNE DUEGNE
    La nuit est fort obscure,
Garre l'eau,

DON JAPHET
    Garre l'eau! bon Dieu! la pourriture,
Ce dernier accident ne promet rien de bon:
Ah, chienne de Duegne, ou servante, ou Demon,
Tu m'as tout compissé, pisseuse abominable,
Sepulchre d'os vivans, habitacle du Diable;
Gouvernante d'Enfer, épouvantail plâtré,
Dents & crins empruntez, & face de châtré.

LA DUEGNE
Garre l'eau,

DON JAPHET
    La diablesse a redoublé la dose.
Execrable Guenon, si c'estoit de l'eau rose
On la pourroit souffrir par le grand froid qu'il fait;
Mais je suis tout couvert de ton deluge infect,
Et, quand j'espererois le retour de ma Belle,
Estant tout putrefait que ferois-je avec elle?
…
Que maudit soit l'amour, & les Balcons maudits
D'où l'on sort tout couvert d'urine, & sans habits:
Que le mestier d'amour est un rude exercice!]

13   *Les Bas-fonds du baroque*, exh. cat. (Rome: Villa Medici; Paris: Musée du Petit Palais, 2015), pp. 140–141; a motif that had already appeared by the beginning of the sixteenth century in a woodblock print by Hans Baldung Grien, showing a drunken Bacchus pissed on by a *putto* perched on a wine cask and holding aloft a flaming torch (fig. 129).

14   Pliny the Elder, *Natural History*, trans. W. H. S. Jones, vol. 8, *Books 28–32*, Loeb Classical Library 418 (Cambridge, Massachusetts: Harvard University Press, 2006), pp. 47–49. See also the long chapter Bourke devotes to excrement and urine in medicine, *Scatalogic Rites of All Nations*, pp. 277–369.

15   See Thierry Berrod and Quincy Russell, *Les superpouvoirs de l'urine*, television documentary, 2013, 57:25, broadcast on ARTE on November 14, 2014, https://www.youtube.com/watch?v=geaNthBisZ8.

16   Bourke, *Scatalogic Rites of All Nations*, p. 211.

17   Bourke, *Scatalogic Rites of All Nations*, pp. 203–205.

18   Sigmund Freud, "The Acquisition and Control of Fire," in *The Standard Edition of the Complete Psychological Works of Sigmund Freud*, trans. James Strachey, vol. 22, *1932–1936: New Introductory Lectures on Psycho-Analysis and Other Works* (London: The Hogarth Press, 1964), pp. 191–192.

*In a strange engraving signed M Inuentor / SL Sculpton [sic], a naked, horned child looses a thick stream of piss onto a coffin covered by a cloth marked with a cross. He is in mid-stride with his right foot in the air, while his left stamps on an open book placed on the coffin, itself resting on a stretcher at the edge of an abyss (fig. 132). He is led by a chain in the hand of a devil, also horned, who looks on, snickering. The child holds a sword in his right hand and, in his left, a stick that rests on his shoulder, at the end of which hangs a crown on the verge of falling, while gold coins slip out of the torn sack he wears slung across his chest. Flames dance in the background, a thick vapor rises from the rear of the scene and two flying monstrosities emerge from it, ready to attack ... Energetic burin work gives a sense of urgency to this torrent of enigmas, in which Eduard Fuchs, who reproduced it, saw a caricature of greed (*Deutsch obszöne Karikatur auf den Geiz*), and Ilja Veldman an allegory for impure desires.[1] A mystery, in short, until David Monteau pointed out to me a woodblock print in a catalog from the British Museum, an illustration in the* Büchlein vom Zutrinken *by Johann von Schwarzenberg, 1463–1528, a humanist, jurist, moralist, and friend of Luther. This* Little Book of Drinking *introduced the devil among the drunks, and in the last of five plates by Jörg Breu the Elder, we find again the naked, horned child pissing on a coffin (fig. 133).[2] He wears a crown of grapevines on his head, his two feet are on the sizable open book (described by Scheel as a code of law,* Gesetzbuch*), the gold coins slip*

*from his sack, and a massive, hairy devil, his mouth hang-*
*ing open, pulls on the boy's chains, while the background*
*fills with flames and smoke. The image closes the chapter*
*"Von den höllischen wunderwerken imm zutrincken" ("On*
*the infernal prodigies of drinking"). The engraving by M/*
*SL seems to be a later elaboration that dramatizes the im-*
*age and its moral: the child pisses while walking with an as-*
*sured step, the devil, dressed—his horns pierce his hat—and*
*now bearing the same porcine head as the devil with multi-*
*ple breasts that illustrates the* Harrowing of Hell *by Dürer*
*in* The Large Passion *of 1510, brandishes a tall, decorated*
*goblet in the child's direction; the crown is at the end of the*
*rod, almost falling, the stream of piss more eloquent. The*
*smoke in the background is even thicker, and the monstrous*
*vampire-leeches that escape from it complete this little com-*
*pendium of horrors.*

*Christopher Wood is of the opinion that the engraving is*
*later than it seems, probably a pastiche dating to the nine-*
*teenth century.*

---

1   Fuchs, *Illustrierte Sittengeschichte*, p. 274. Ilja M. Veldman's hypothesis
    was related to me by Carel Blotkamp; my gratitude to both of them. Veld-
    man reproduced and discussed a series of engravings with related sub-
    ject matter, by Coornhert in imitation of Van Heemskerck, in his book
    *Images for the Eye and Soul: Function and Meaning in Netherlandish Prints
    (1450–1650)* (Leiden: Primavera Pers, 2006), pp. 75–77.

2   The *Büchlein vom Zutrinken* was published as part of *Der Teutsch Cicero*
    (Augsburg: Steiner, 1534); for this print, see *Der Teutsch Cicero*, fol. 92. The
    text of the *Büchlein vom Zutrinken* was republished without the plates by
    Willy Scheel (Halle: Niemayer, 1900). My thanks to Gabriel Montua.

# Pissed Art

When the League of Nations feebly condemned the Italian invasion of Ethiopia, on November 18, 1936, fascist propaganda parried with postcards featuring toddlers, nude but for shoes and berets, pissing on the sanctions, *le sanzioni* (figs. 134a–134b).[1] Renaissance imagery of urinating *spiritelli* was photographically reprised to broadcast the contempt with which the new Italian Empire, now in its fourteenth year, would treat the toothless international organization.

*Pissing on* or *pissing against* as an act of aggression has a pedigree that goes back millennia. The Greek rhetorician Diogenes Laertius reports that when dinner guests would throw bones to Diogenes the Cynic, as if he were a dog, he would crawl over and piss on them, as if he were a dog.[2] Today, in the Polish working-class city Nowa Huta, the statue of a fluorescent yellow Lenin pissing in mid-stride, the work of a husband-and-wife team, the Szydłowskis, is intended to rid the country of its communist ghosts through "laughter and distance" (fig. 135).

Of course, art can just as easily turn the offensive stream against itself. The *Fountain* that Duchamp signed as R. Mutt is *a priori* empty of urine, but its title, as with the later *Tu m'*, along with the object's relocation from the public bathroom to the exhibition hall of the Society of Independent Artists in New York, express perfectly well an anti-art aggression. The message was clearly understood by the majority of the exhibition's organizers in 1917: "its place is not in an art exhibition."[3] When *Fountain* was finally, after a handful of decades, admitted into the art

historical canon (in 1999, one of the eight replicas created in 1964 for Arturo Schwarz was sold to the Greek financier Dimitris Daskalopoulos for $1,762,500), it became inevitable that it would eventually attract the very thing it was missing. In 1993, the performance artist Pierre Pinoncelli pissed into a Schwarz replica in Nîmes and damaged it with a hammer, thereby paying homage to the Duchampian anagram: "Ruiner, uriner" (urinate, ruinate).[4] He committed the same infraction thirteen years later in Paris (without piss). These replicas were, as Patrick de Haas has reminded me, not real urinals, but reproductions of the 1917 Mott model, commissioned by Schwarz and based on Stieglitz's photograph of the original: instead of readymades, they are therefore anti-readymades. Duchamp intended to scandalize the art world, but the art world transmuted his attempt at scandal into more art (and so into money). Pinoncelli vandalized the *artification* of scandal, but his piss was meant as an act of love for Duchamp, a final addition that would complete the master's work. The Musée National d'Art Moderne demanded €2,800,000 in damages without success, and Pinoncelli's urinal found a more modest home in the Musée d'Art Moderne et d'Art Contemporain in Nice.

Duchamp, scion of a provincial notary, had impeccable manners; the same couldn't be said for Jackson Pollock, the son of a farmer, raised in the American West and accustomed to pissing outdoors. In 1935, with his brother Sande, he covered the walls of his uncomfortable apartment on West Houston with large, aggressively

pornographic paintings in the style of the Mexican muralist Orozco, featuring, as a friend recalled, images of "guys peeing all over." He was a mean drunk, and he showed it by pissing into the fireplace or flowerpots of his hosts, or on the floor, or else in his own bed or the beds of his friends: "Inevitably, a rumor began to circulate that Jackson *did* urinate on his canvases." [5] After all, he poured all sorts of objects onto some of them: 1947's *Full Fathom Five* includes nails, pins, keys, a comb, buttons, discarded paint-tube caps, broken cigarettes, and matches, all of it buried under a dense web of paint. But considering the astronomical prices a Pollock fetches today, one could be tempted to imagine the assessors had detected some slight trace of a urine rarer than gold, in the way that experts working with the FBI found traces of Duchamp's semen in his 1946 *Paysage fautif*.

At the end of Pasolini's book and film *Teorema*, Pietro, the uptight son of a bourgeois family in thrall to the incredible beauty of "the guest" who has made love to each of them and abandoned each of them in turn, devotes himself to painting: his erotic talisman is a print of a modern canvas (Wyndham Lewis in the book, Francis Bacon in the film), which he had previously contemplated alongside the mysterious visitor.[6] He tries to remember the now-departed guest's face, tries to draw it and fails, and tries again at an ever larger scale. He employs new techniques on transparent supports, covers an entire surface in blue—the blue of the visitor's eyes—and finally comes to the conclusion that he only paints

now and has only ever painted in order to make his impotence visible to all. "Seized by a ferocious impulse of hatred—or else with the slightly vulgar calm of someone who has weighed things up—from his squatting position in front of his picture he stands up straight, unbuttons his trousers and pisses on it." [7] A failure, a gratuitous act, an impasse. Pasolini commented: "This extremism is typical of classic avant-gardes, and neo-avant-gardes as well.... It aims at a beyond to psychology. When they do reintroduce psychology, they give it an insane, blasphematory, even excremental aspect.... It's also an excessive hyper-intensification of subcultural conflict, which elevates iconoclasm into a complete cultural system." [8]

He filmed the boy painting through a pane of glass, as Hans Namuth had filmed Pollock twice at work on his own painting on glass, *No. 29, 1950*, but Pasolini adds an uncompromising monologue: "New techniques—they must be unrecognizable ones—have to be invented which resemble no other previous operation.... To construct a world of one's own with which no comparisons are possible. For which no criteria exist.... No one must see that the author is worthless, that he is an abnormal, inferior being, like a worm writhing in order to survive.... Everything must present itself as perfect, based on *unknown rules* and therefore impossible to judge.... But everyone must think that this is not a case of the expedient of someone lacking in skill, of someone who is *impotent*—but that on the contrary it is a case of a sure, undaunted decision that is haughty and almost

overweening: a newly invented and almost irreplace-
able technique." [9] Pasolini, a close associate of a diverse
group of figurative artists, including Renato Guttuso,
Ottone Rosai, Giorgio Morandi, and Filippo de Pisis, con-
demns the excesses of the avant-garde using Pietro as a
mouthpiece. Two chapters later, Pietro, his eyes closed,
undertakes a blue pastiche of one of Pollock's poured
paintings, and "ends up by losing or betraying God." [10] Of
course, it's well known that one generation's grotesque
exaggeration can become the next generation's new nor-
mal: Malevich's black square was the victim of antici-
patory parodies by Bertall, the Incoherents, and Paul
Iribe. [11] In 1977–1978, Andy Warhol, who owned one of the
Schwarz *Fountains*, a surplus copy he bartered for in New
York, began work on a series of pissed paintings. Warhol,
his assistants Ronnie Cutrone and Walter Steding, the
mustachioed Venezuelan Victor Hugo (then a central fig-
ure in the New York gay scene), and a handful of recruits
gathered by Hugo all voided their bladders on canvases
laid on the ground and, often but not always, prepared
with metallic paint. The canvases were sometimes of
gigantic proportions, in the format of Pollock's enor-
mous compositions. $C_5H_4N_4O_3$ and other adventitious
molecules (vitamin B, etc.) induced green or blackish
reactions depending on the particular kind of metallic
paint being used (fig. 136). Warhol also made a number
of paintings with semen; [12] he mentions one of them in
his diary entry for December 24, 1978 (a Christmas pres-
ent for one of his friends, a fashionable British woman),

but he can no longer remember whether its production involved his own ejaculate or Victor's.

As he was nearing fifty, perhaps bored with portraying the mundanities of the moment and not wanting to lose his grip on the art world, Warhol involved himself in a series of more aggressive enterprises, including pornographic drawings, photographs, and paintings, e.g., *Torsos* and *Sex Parts*. Gay sexuality, then, was sometimes brutal: leather, fist fucking, and water sports. In a number of New York clubs—the Toilet, the Eagle's Nest—piss took pride of place, at the same time that Mapplethorpe was photographing *Jim and Tom, Sausalito* on the other side of the country. According to Bob Colacello, former editor-in-chief of *Interview*:

> I'm pretty sure that the Piss Paintings idea came from friends telling him about what went on at the Toilet, reinforced perhaps by the punks peeing at his Paris opening [at Galerie Daniel Templon]. He was also aware of the scene in the 1968 Pasolini movie, *Teorema*, where an aspiring artist pisses on his paintings. "It's a parody of Jackson Pollock," he told me, referring to rumors that Pollock would urinate on a canvas before delivering it to a dealer or client he didn't like. Andy liked his work to have art-historical references.[13]

Warhol, who in his diary on March 19, 1978, records a discussion with Dalí about the pissed canvas in *Teorema*, was surely aware of it even earlier, since Pasolini had prepared

the Italian version of *Trash* and had written, just before his death, a catalog essay on Warhol's portraits of transvestites.[14] But according to Ronnie Cutrone, the idea had come even earlier: in 1961–1962, Warhol had pissed on white canvases and placed canvases on the street in front of his apartment so that passersby would walk on them.[15] In 1976, in response to a question from the magazine *Unmuzzled Ox* about his older abstract work, Andy answered:

> The only ones I have are the piss paintings; I have a couple. That was a long time ago. Then there were the canvases that I used to leave on the street and people used to walk on them; in the end I had a lot of dirty canvases. Then I thought they were all diseased so I rolled them up and put them somewhere.[16]

Perhaps the interview reawakened a dormant fantasy, and provoked the torrent of urinary paintings that came a year or two later. The piss paintings were the first canvases created without screen printing, inaugurating a series of decorative abstractions and semi-abstractions, the *Shadows*, *Eggs*, *Gems*, *Knives*, *Crosses*, *Rorschach*, and *Camouflage* series.[17] The *Oxidation* works presented themselves as pure painting, the culmination of the artist's taste for textures and surfaces. A few years later, he treated the face of Jean-Michel Basquiat (in 1982, fig. 137) and the skull of Philip Niarchos (in 1983 and 1985) with an oxidizing stream of urine.[18] The aestheticization of piss provoked contradictory reactions:

With the Oxidation series, Warhol seems at last to ex-
press a clear attitude toward his art: utter contempt.
Or is he contemptuous of himself? Of his audience?
There is also the possibility that Warhol's Oxidation
process is a vicious, infantile mockery of Jackson
Pollock's paint slinging. Between Warhol's intention
and its result an immeasurable distance unfolds.
Considering how it was executed, the prettiness of
the Oxidation images is disturbing. Yet these canvases
are as blandly attractive as any Warhol has ever made,
including the pastel-tinted Sunsets of 1972. Perhaps
he meant no insult to himself or anyone else. Warhol
may see urination as simply a way of finding an image,
no better or worse than any other.[19]

Warhol liked the play of violent contrasts, aestheticizing
death with pretty electric chairs, graceful suicides, gro-
tesque accidents, and atomic explosions. But here the
contradiction is in urine itself, and in the ambivalent feel-
ings it arouses: luminous and more or less voluptuous
in the intimacy of its discharge, but rather repulsive to
smell when it's not one's own, indicating the presence
of a potential rival. And yet, how many individuals dis-
inhibit themselves through drugs, alcohol, or sexual ex-
citement to the point that they return to archaic and in-
stinctual approaches to urination. The *Oxidation* works
have retained their aggressive capacity mostly in their
persistent odor, which Victor Bockris complained of in
his biography of Warhol; but when they were displayed

in galleries, under the glare of the spotlights, the canvases came alive:

> When I showed them in Paris, the hot lights made them melt again; it's very weird when they drip down. They looked like real drippy paintings [an allusion to Pollock's drip paintings]; they never stopped dripping because the lights were so hot. Then you can understand why those holy pictures cry all the time.[20]

Not just anyone makes a good pisser. "If I asked somebody to do an *Oxidation* painting, they just wouldn't think about it and it just would be a mess. Then I did it myself. You know it's too much work … when someone comes to try to figure out a good design or something like that." [21] Head and cock have to be in agreement: it's not enough to just piss, you also need to know how to move the instrument and direct the stream ("[the *Oxidations*] had technique, too"), as Pollock knew how to move his painting stick on the canvas.

Andy Warhol, who once referred to himself as a "quasi-romantic, at least," [22] and who claimed to have created a perfume he christened Urine, packaged in a Coca-Cola bottle,[23] perhaps leveled the same aesthetic gaze on piss that he did on everything else, one we can also find in a contemplative note written by Coleridge at the end of December 1803: "What a beautiful Thing Urine is, in a Pot, brown yellow, transpicuous, the Image, diamond shaped of the of the [sic] Candle in it, especially, as it

now appeared, I having emptied the Snuffers into it, &
the Snuff floating about, & painting all-shaped Shadows
on the Bottom." [24]

1   Brought to my attention by Éric Michaud.

2   Diogenes Laertius, *Lives of Eminent Philosophers*, 6.2.46.

3   *New York Herald*, April 14, 1917, p. 6; quoted in William A. Camfield, *Marcel Duchamp: Fountain*, exh. cat. (Houston: The Menil Collection and Houston Fine Art Press, 1989), p. 27, and in Francis M. Naumann, *The Recurrent, Haunting Ghost: Essays on the Art, Life, and Legacy of Marcel Duchamp* (New York: Readymade Press, 2012), p. 72.

4   My gratitude to Philippe Comar for reminding me of this. Marcel Duchamp, *Duchamp du signe* (Paris: Flammarion, 1975), p. 160.

5   Steven Naifeh and Gregory White Smith, *Jackson Pollock: An American Saga* (New York: Potter, 1989), pp. 263, 280, 541, 876n.

6   Pier Paolo Pasolini, *Theorem*, trans. Stuart Hood (London: Quartet Books, 1992), pp. 35, 115; see Francesco Galluzzi, *Pasolini e la pittura* (Rome: Bulzoni, 1994), p. 182. The son, Pietro, and the father, Paolo, are named after the author.

7   Pasolini, *Theorem*, p. 127.

8   Jean Duflot, *Entretiens avec Pasolini* (Paris: Belfond, 1970), p. 109; Galluzzi, *Pasolini et la pittura*, p. 185.

9   Pasolini, *Theorem*, pp. 125–126.

10  Pasolini, *Theorem*, pp. 133–134.

11  Bertall, *L'Illustration*, May 1843 (see *Arts incohérents, académie du dérisoire*, exh. cat. [Paris: Musée d'Orsay, 1992], p. 18); Paul Bilhaud, *Negroes Fighting in a Tunnel*, 1882, shown in the first exhibition of Incoherent work that same year; Paul Iribe, *Pudeur*, in *Le Témoin*, November 27, 1909, captioned: "Ah, no! I beg of you . . . leave me my pearl necklace, at least!"

12  *Andy Warhol: Piss & Sex Paintings and Drawings*, exh. cat. (New York: Gagosian Gallery, 2002), p. 56 (a small-scale polyptych on canvas).

13  Bob Colacello, *Holy Terror: Andy Warhol Close Up* (New York: Vintage, 2014), p. 456.

14  Galluzzi, *Pasolini e la pittura*, pp. 144–146.

15  Ronnie Cutrone, interview with Patrick S. Smith, December 13, 1978, in Patrick S. Smith, *Andy Warhol's Art and Films* (Ann Arbor, Michigan: UMI Research Press, 1986), p. 287.

16  *Unmuzzled Ox* 4, no. 2 (1976): p. 44; one of these canvases is reproduced on p. 45 and dated "c. 1961." It also appears in color (and rotated 90 degrees) in Hervé Vanel, ed., *Warhol Unlimited*, exh. cat. (Paris: Éditions Paris Musées, 2015), p. 20.

17  *Andy Warhol abstrakt*, exh. cat. (Munich: Prestel, 1993).

18  *Andy Warhol: The Last Decade*, exh. cat. (Milwaukee, Wisconsin: Milwaukee Art Museum, 2009), pp. 32, 76. With thanks to Neil Printz, editor of the Warhol catalogue raisonné, who was kind enough to confirm some of these dates.

19  Carter Ratcliff, *Andy Warhol* (New York: Abbeville, 1983), pp. 94–97.

20  Andy Warhol, interview with Benjamin H. D. Buchloh, May 1985, in *Andy Warhol: The Late Work*, exh. cat. (Düsseldorf: Kunst Palast; Munich: Prestel, 2004), p. 114. A slightly different version of this interview appears in Kenneth Goldsmith, ed., *I'll Be Your Mirror: The Selected Andy Warhol Interviews, 1962–1987* (New York: Carroll & Graf, 2004).

21  Ibid.

22  Andy Warhol, interview with Ruth Hirschman and Taylor Mead, 1963, in Goldsmith, *I'll Be Your Mirror*, p. 31.

23  Andy Warhol, interview with Jordan Crandall, 1986, in Goldsmith, *I'll Be Your Mirror*, p. 365. The perfume bottle is reproduced on p. 15 of Vernel, *Warhol Unlimited*, with the title *You're In*, also known as *Eau d'Andy* (1967).

24  Kathleen Coburn, ed., *The Notebooks of Samuel Taylor Coleridge*, vol. 1, *1794–1804*, part 1 (New York: Pantheon Books, 1957), note 1766.

# Figures

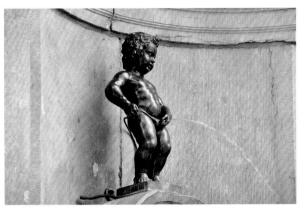

1     Replica of Jérôme Duquesnoy the Elder, *Manneken-Pis*, 1619.
       21 ⅞ inches | 55.5 cm. Rue de l'Étuve, Brussels
2     Alfred Machin, *Saïda a enlevé Manneken-Pis* (still), 1913. Black-and-
       white film, silent, 7 min.

LITTLE JULIEN

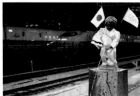

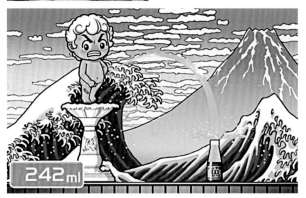

3a    Unsigned postcard, *Rivalry from the Marolles Kids*, n.d.
3b    Unsigned German postcard, 1906. Chromolithograph, series 543.
       Postcard Museum, Antibes. Photo: Christian Deflandre
4       Copy of *Manneken-Pis*, 1968. Bronze (the original, from 1952, was made
       of white bone china). Hamamatsuchō Station, Tokyo. Gift from
       Hikaru Kobayashi
5       Sega Corporation, *Toylet*, 2011. Japanese video game

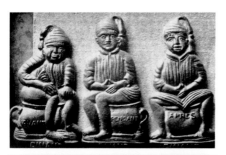

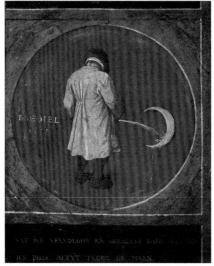

6    *Honey cake, Dinant*, illustration from Anatole Jakovsky, *Éros du dimanche* (Paris: Éditions Pauvert, 1964), p. 228

7    Pieter Bruegel the Elder, *Twelve Flemish Proverbs* (detail), c. 1558. "Some of the goals I pursue, I never reach. I continue pissing at the moon." Oil on wood, 28 ⅜ × 38 ¾ inches | 74.5 × 98.4 cm. Museum Mayer van den Bergh, Antwerp. Photo: Michel Wuyts

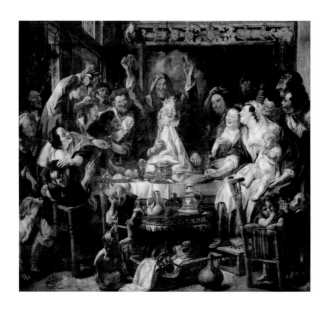

8    Jacob Jordaens, *The King Drinks*, 1660. Oil on canvas, 102 ¾ × 111 ⅜ inches | 261 × 283 cm. Museum of Fine Arts, Tournai

LITTLE JULIEN

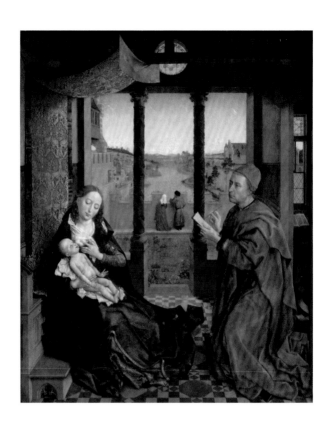

9a    Rogier van der Weyden, *Saint Luke Drawing the Virgin*, c. 1435–1440.
Oil and tempera on panel, 54 ⅛ × 39 ¾ inches | 137.5 × 100.8 cm.
Museum of Fine Arts, Boston. Photo: Guillaume Cassegrain;
bc. details

LITTLE JULIEN

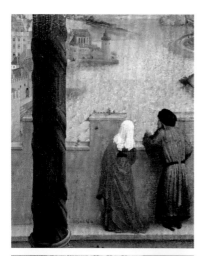

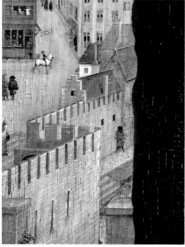

LITTLE JULIEN

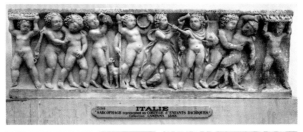

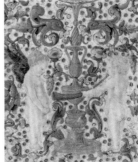

10   Roman sarcophagus, procession of Bacchic children (Dionysus is
     the fifth child from the left, carrying the thyrsi and a tambourine),
     Italy, end of the third century. Marble. Inv. No. MA605. Musée du
     Louvre, Paris, France. Photo: Pierre and Maurice Chuzeville.
     © Musée du Louvre, Dist. RMN-Grand Palais / Pierre and Maurice
     Chuzeville / Art Resource, NY

11   *Hermaphrodite. Bronze statue discovered in Rome*, illustration from
     Salomon Reinach, *Cultes, mythes et religions*, vol. 2 (Paris: Ernest
     Leroux, 1906), p. 335

12a  *Commentary* of Duns Scotus (detail), 1462. Manuscript, Vat.lat.888,
     fol. 1r, 14 1/8 × 9 3/4 inches | 36 × 24.8 cm; b. Ptolemy's *Geography*
     (detail), 1472. Manuscript, Urb.lat.277, fol. 2r, 23 3/8 × 17 1/8 inches |
     59.3 × 43.5 cm. Vatican Library, Rome

13　Simon Bening, Grimani Breviary, *The Month of February*, c. 1510–1520.
　　Manuscript, fol. 2v, 11 × 7 ⅝ inches | 28 × 19.5 cm. Department of Rare
　　Books, Biblioteca Nazionale Marciana, Venice

14a　Giuliano Bugiardini and Francesco Granacci, *Scenes from the Life of
　　the Young Tobias*, c. 1500. Oil on poplar wood panel, 23 ⅖ × 62 ¼ inches |
　　59.5 × 158 cm. Inv. No. 149. Gemäldegalerie, Staatliche Museen, Berlin,
　　Germany. Photo: Jörg P. Anders. Photo Credit: bpk Bildagentur /
　　Staatliche Museen / Jörg P. Anders / Art Resource, NY; b. detail

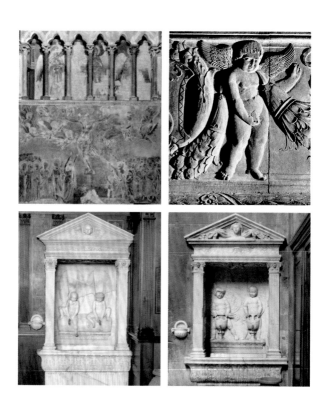

15 Cenni di Pepo (Cimabue) and workshop, *Three Angels* and *Crucifixion*, c. 1280. Upper church, south transept, Basilica of Saint Francis of Assisi, Assisi. Photo: Stefan Diller

16 Workshop of Agostino di Duccio, frieze, c. 1460. Chapel of the Liberal Arts, Tempio Malatestiano, Rimini

17ab Andrea di Lazzaro Cavalcanti (il Buggiano) and Pagno di Lapo Portigiani, washbasins, c. 1438–1445. White marble. North and south sacristies, Santa Maria del Fiore, Florence. Photos: Nicolò Orsi Battaglini

*SPIRITELLI*

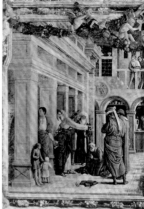

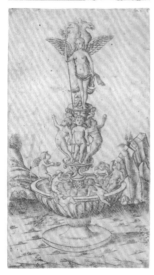

18a   Andrea Mantegna, *Saint James Baptizing Hermogenes* (detail),
c. 1450–1454. Fresco (destroyed). Ovetari Chapel, Eremitani Church,
Padua; b. digital reconstruction

19     Unsigned, *Fountain*, Ferrara, c. 1470–1480. Engraving, 7 ⅛ × 4 inches |
18 × 10.1 cm. British Museum, London

*SPIRITELLI*

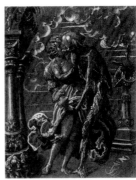

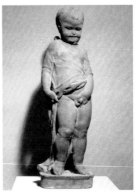

20a Niklaus Manuel Deutsch, *Bathsheba at the Bath* (recto), 1517.
Mixed media on pine, 15 × 7 ½ inches | 38.2 × 19.2 cm. Amerbach-
Kabinett, Kunstmuseum Basel. Photo: Marin P. Bühler; b. *Death as
a Mercenary Taking a Young Woman* (verso)

21 Unsigned, *Pisser's Fountain*, 1399–1559. Cast iron, granite, and bronze.
Lacaune-les-Bains, Tarn

22 Circle of Donatello, *Urinating Putto*, fifteenth century. Pietra serena,
25 inches | 63.5 cm. Inv. No. RF660. Musée du Louvre, Paris, France.
Photo: Pierre Philibert. © Musée du Louvre, Dist. RMN-Grand Palais /
Pierre Philibert / Art Resource, NY

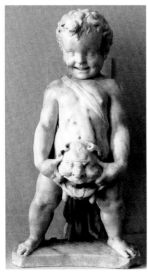

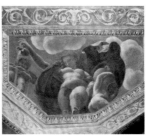

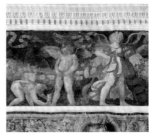

23  Pierino da Vinci, *Fountain*, c. 1544–1550. Marble. National Museum of
    Modern and Medieval Art, Arezzo
24  Giulio Romano, *Nymph Pouring Water from a Pot, Putto Urinating, and
    Another Putto Holding a Jar*, 1528. Oil on stucco. Ceiling of the Sala
    di Psiche, Palazzo del Te, Mantua
25  Giulio Romano, *Putto Pissing in a Jug* (detail), c. 1520–1530. Room of the
    Frieze of Love, Villa Madama, Rome

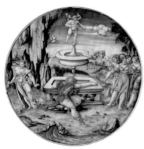

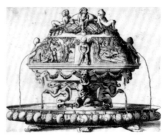

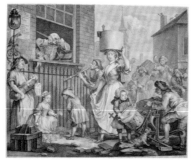

26    Attributed to Francesco Xanto Avelli da Rovigo, *Narcissus at
      the Fountain of Love*, Urbino, c. 1525–1526. Tin-glazed earthenware,
      10 ⅞ inches | 27.6 cm. Wallace Collection, London
27    Attributed to René Boyvin after Léonard Thiry, *Study for a Table
      Fountain*, c. 1550–1560. Engraving, 5 × 6 ⅜ inches | 13 × 16.3 cm.
      British Museum, London
28    William Hogarth, *The Enraged Musician*, 1741. Engraving and
      etching, 14 ⅛ × 16 inches | 36 × 40.8 cm. British Museum, London

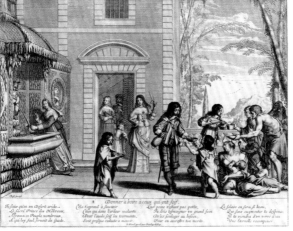

29  Hubert Robert, *Laundress and Child*, 1761. Oil on canvas, 13 ⅞ × 12 ½ inches | 35.1 × 31.6 cm. Clark Art Institute, Williamstown, Massachusetts

30  Abraham Bosse, *The Works of Mercy: Giving Drink to the Thirsty*, c. 1635. Etching, 10 ⅛ × 12 ⅞ inches | 25.8 × 32.7 cm. British Museum, London

*SPIRITELLI*

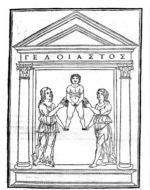

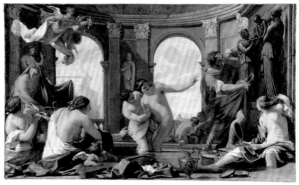

31    Unsigned illustration from Francesco Colonna, *Hypnerotomachia Poliphili* (Venice: Aldus Manutius, 1499), fol. E7r. University of Virginia Library, Charlottesville

32    Unsigned illustration from Francesco Colonna, *Hypnerotomachie, ou Discours du songe de Poliphile* (Paris: Jacques Kerver, 1546). University of Virginia Library, Charlottesville

33    Eustache Le Sueur, *Poliphilus at the Bath of the Nymphs*, c. 1640. Oil on canvas, 37 × 61 inches | 94 × 156 cm. Inv. No. 1938F641. Musée Magnin, Dijon, France. Photo: Daniel Chenot. © RMN-Grand Palais / Art Resource, NY

*SPIRITELLI*

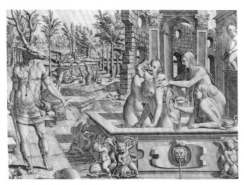

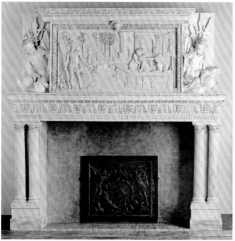

34    Jean Mignon after Luca Penni, *Diane and Actaeon*, c. 1545–1555.
      Etching, 12 ¼ × 16 ¾ inches | 31 × 42.6 cm. British Museum, London
35    After Jean Mignon, *Diana Surprised by Actaeon in the Bath*, c. 1567.
      Stone fireplace, Hôtel Hugues Lallemant (destroyed), Châlons-en-
      Champagne. National Museum of the Renaissance, Écouen

*SPIRITELLI*

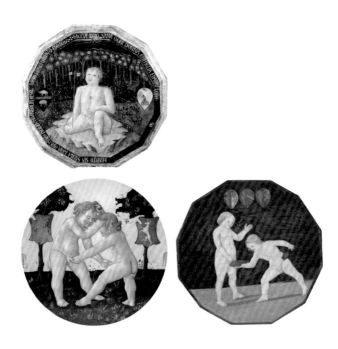

36    Bartolomeo di Fruosino, *desco da parto* (verso), 1428. Tempera, gold, and silver on panel, 24 ¾ inches | 62.9 cm. Private collection

37a   Giovanni di Ser Giovanni (lo Scheggia), *desco da parto* (verso), c. 1450. Tempera on wood. Palazzo Davanzati Museum, Florence

37b   Workshop of Apollonio di Giovanni, *desco da parto* (verso of *Triumph of Chastity*), c. 1450–1460. Tempera and gold leaf on panel, 23 × 23 ¼ inches | 58.4 × 59.1 cm. North Carolina Museum of Art, Raleigh

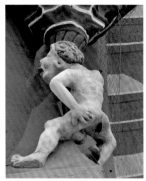

38 German stamp with illustration from the Brothers Grimm's *The Table, the Ass, and the Stick*

39 Unsigned, *Dukatenscheißer*, n.d. Sculpture on façade. Hotel Kaiserworth, Goslar

40 Unsigned, *Dukatenscheißer*, n.d. Sculpture on façade. Stadtsparkasse, Bolkerstraße, Düsseldorf

*SPIRITELLI*

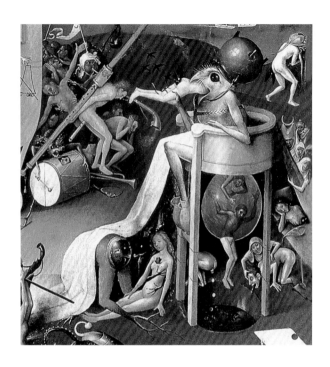

41    Hieronymous Bosch, *The Garden of Earthly Delights* (detail),
c. 1500–1505. Oil on wood, 86 ⅝ × 153 ⅛ inches | 220 × 389 cm. Museo
Nacional del Prado, Madrid

42    Pieter Bruegel the Elder, *Dulle Griet* (*Mad Meg*), c. 1562. Oil on panel, 46 ¼ × 63 ¾ inches | 117.4 × 162 cm. Museum Mayer van den Bergh, Antwerp

*SPIRITELLI*

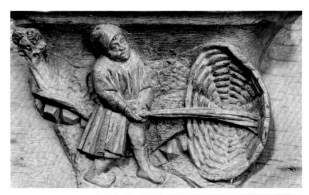

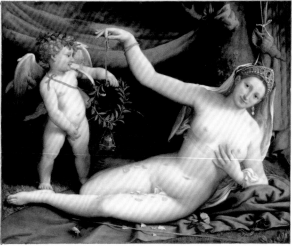

43    Richard Falaise, carved stall, 1522. Oak. Collegiate Church Saint-Martin, Champeaux, Seine-et-Marne

44    Lorenzo Lotto, *Venus and Cupid*, c. 1525. Oil on canvas, 36 ⅜ × 43 ⅞ inches | 92.4 × 111.4 cm. Metropolitan Museum of Art, New York

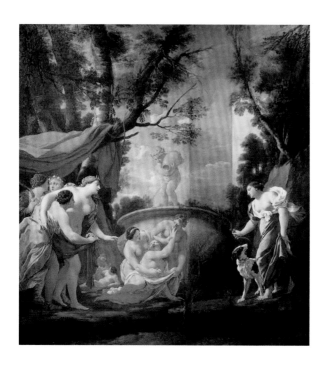

45    Michel Dorigny, *Diana Discovering the Pregnancy of Callisto*,
      c. 1635–1640. Oil on canvas, 9 × 8¼ inches | 22.8 × 20.9 cm. Petit Palais,
      Musée des Beaux-Arts de la Ville de Paris

LOTTO

*Charmante Gabrielle je veux vous faire au sort fee de sous officier*
*de 2.eme Hussard.*

46    Jacques-Antoine Vallin, *Three Nymphs next to the Fountain of Love*,
      beginning of the nineteenth century. Oil on canvas, 15 ⅞ × 12 ¾ inches |
      40.3 × 32.4 cm. Private collection
47    Unsigned, *Charmante Gabrielle . . .* , c. 1830. Color lithograph.
      Private collection

LOTTO

nota petra opportunamete accenorie, Et in que imaguentie, qtiqi par
uicule, Niente di meno, defecto alcuno, & nelle minime parte se accusa
ua. Ma omni parte distinctaméte pfecta cerneuase.

48a  Lorenzo Lotto, ceiling fresco, 1524. Suardi Oratory, Trescore; b. detail
49    Unsigned illustration from Francesco Colonna, *Hypnerotomachia
     Poliphili* (Venice: Aldus Manutius, 1499), fol. L4r. University of Virginia
     Library, Charlottesville

LOTTO

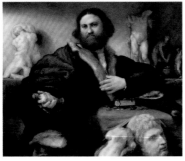
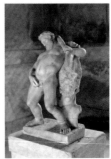

50    Lorenzo Lotto and Giovan Francesco Capoferri, *Judith and Holofernes*, 1527. Marquetry, 27 ½ × 40 ½ inches | 70 × 103 cm. Basilica di Santa Maria Maggiore, Bergamo

51    Lorenzo Lotto, *Andrea Odoni*, 1527. Oil on canvas, 41 × 46 inches | 104.3 × 116.8 cm. Picture Gallery, Buckingham Palace, London

52    Unsigned, *Hercules, Drunk while Urinating*, High Roman Empire. White marble. House of the Stags, Herculaneum. Photo: Giuliano Valsecchi

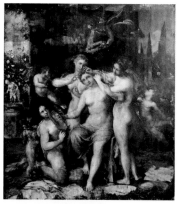

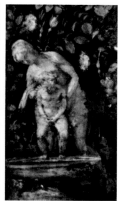

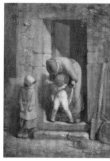

53a   Attributed to Lorenzo Lotto, *Toilet of Venus*, c. 1530–1550. Oil on canvas, 70 ½ × 60 inches | 179 × 152 cm. Private collection, Bergamo; b. detail

54     Jean-François Millet, *Maternal Care*, c. 1855–1857. Oil on wood, 11 ³⁄₈ × 8 ⅛ inches | 29 × 20.5 cm. Musée du Louvre, Paris

55     Lorenzo Lotto, *Study of an Angel* (verso of *Saint Peter and Saint Paul Supporting a Monstrance*), 1543. Charcoal on paper, 11 ½ × 7 ⅞ inches | 29.2 × 20 cm. Fitzwilliam Museum, University of Cambridge

LOTTO

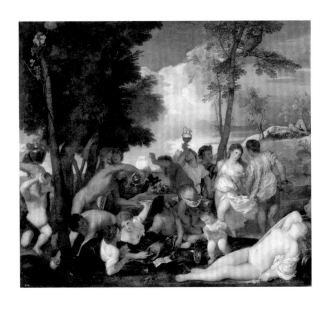

56    Titian, *The Bacchanal of the Andrians*, c. 1523–1526. Oil on canvas,
      68⅞ × 76 inches | 175 × 193 cm. Museo Nacional del Prado, Madrid

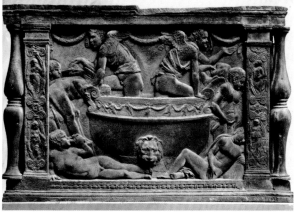

57    Unsigned illustration from Francesco Colonna, *Hypnerotomachia Poliphili* (Venice: Aldus Manutius, 1499), fol. E1r. Jean Bonna Library, Geneva

58    Donatello, *Judith and Holofernes* (base), c. 1453–1460. Bronze. Palazzo Vecchio, Florence. Photo: Fratelli Alinari

TITIAN

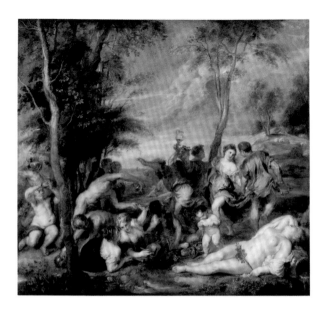

59    Peter Paul Rubens after Titian, *The Bacchanalia on Andros*, c. 1628.
Oil on canvas, 78 ¾ × 84 ⅝ inches | 200 × 215 cm. Nationalmuseum,
Stockholm

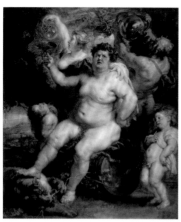

60  Peter Paul Rubens, *Bacchus*, c. 1638–1640. Oil on canvas, 75 ¼ × 63 ½
    inches | 191 × 161.3 cm. State Hermitage Museum, Saint Petersburg
61  Guido Reni, *Drinking Bacchus*, c. 1637–1638. Oil on canvas, 28 ⅜ ×
    22 inches | 72 × 56 cm. Gemäldegalerie Alte Meister, Staatliche
    Kunstsammlungen Dresden

62    Giovanni Battista di Jacopo (Rosso Fiorentino), *Loss of Perpetual Youth*, c. 1536–1539. Fresco and stucco relief. Inv. No. SNPM48. Gallery of Francis I, Château Fontainebleau, France. Photo: Gérard Blot. © RMN-Grand Palais / Art Resource, NY

63    Giovanni Battista di Jacopo (Rosso Fiorentino), *The Death of Adonis*, c. 1535–1537. Fresco and stucco relief. Inv. No. SNPM46. Gallery of Francis I, Château Fontainebleau, France. Photo: Gérard Blot. © RMN-Grand Palais / Art Resource, NY

En fin paruint iusqu'en Colchos Iason,
Là où tenoit Eetez la toison :
Qui remonstre des monstres le danger :
Mais ne le feint de l'emprise estranger

64    Jean Cousin the Elder, *Naked Children Playing among Ruins*, beginning
       of the sixteenth century. Black chalk, brown ink, pen, and brown
       wash on gray paper, 16 ⅕ × 22 ⅘ inches | 41.1 × 58 cm. Inv. No. 33427-recto.
       Musée du Louvre, Paris, France. Photo: Jean-Gilles Berizzi.
       © RMN-Grand Palais / Art Resource, NY

65    René Boyvin after Léonard Thiry, *Jason Arriving in Colchis and
       Embracing King Aeëtes*, pl. 7 of *Book of the Conquest of the Golden Fleece
       by Prince Jason of Thessaly*, 1563. Engraving, 6 ¼ × 9 ⅛ inches | 16 ×
       23.1 cm. British Museum, London

MICHELANGELO

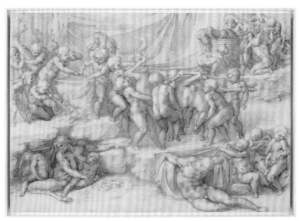

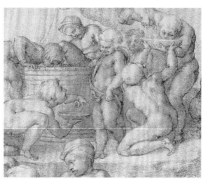

66a   Michelangelo Buonarroti, *Children's Bacchanal*, 1533. Red chalk,
10 ¾ × 15 ¼ inches | 27.4 × 38.8 cm. Windsor Castle; b. detail

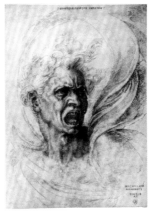

67    Michelangelo Buonarroti, *Drawing with Child, Other Faintly Visible Figures, and Writing*, c. 1522. Preserved in the Room of Drawings and Prints in the Museum of the Uffizi. Gabinetto dei Disegni e delle Stampe, Uffizi, Florence, Italy. Photo: Mannelli, Anchise & Co., c. 1910–1914. Photo Credit: Alinari / Art Resource, NY

68    Michelangelo Buonarroti, *Study of a Man Shouting*, c. 1525. Galleria degli Uffizi, Florence. Photo: Fratelli Alinari

MICHELANGELO

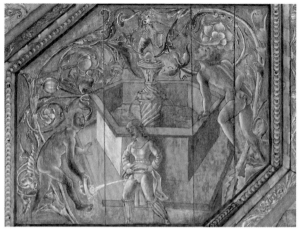

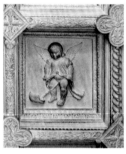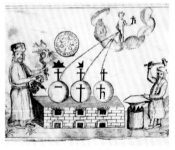

69  Unsigned coffered ceiling, *The Indecent Fountain*, 1468–1473. Paint on
    wood. Room of the Guards, Château du Plessis-Bourré, Écuillé
70  Unsigned coffered ceiling, c. 1500. Oratory, Hôtel Jean Lallemant,
    Bourges. Photo: François Lauginie
71  George Starkey, *Speculum veritatis*, seventeenth century. Manuscript,
    Vat.lat.7286, pl. XVII. Vatican Library, Rome

PISSING GIRLS

72a  Attributed to Simeon ben Cantara, *Cabala mineralis*, seventeenth
century. Manuscript, MS. Add. 5245, fol. 1. British Library, London;
b. fol. 2

PISSING GIRLS

73  Unsigned coffered ceiling, c. 1500. Oratory, Hôtel Jean Lallemant, Bourges. Photo: François Lauginie

74  Lorenzo Lotto and Giovan Francesco Capoferri, *Allegory of the Birth of the Universe*, c. 1524–1531. Marquetry, 21 × 21 inches | 53.5 × 53.5 cm. Basilica di Santa Maria Maggiore, Bergamo

75a  Matthias Gerung, *Melancholia*, 1558. Painting on wood, 34 ⅝ ×
     26 ¾ inches | 88 × 68 cm. Staatliche Kunsthalle Karlsruhe. Photo:
     Annette Fischer/Heike Kohler; b. detail

PISSING GIRLS

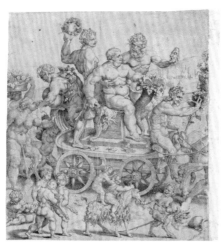

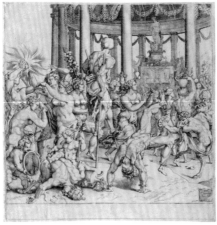

76ab  Cornelis Bos, *The Triumph of Bacchus* (details), 1543. Engraving, 12 ³⁄₈ ×
34 inches | 31.5 × 86.5 cm. Rijksmuseum, Amsterdam

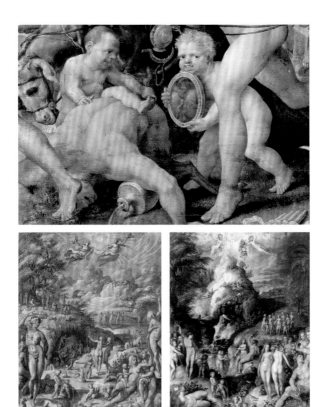

77    Maarten van Heemskerck, *The Triumph of Bacchus* (detail), c. 1536–1537.
      Oil on canvas, 22 × 42 inches | 56 × 106.6 cm. Gemäldegalerie,
      Kunsthistorisches Museum, Vienna

78    Jacopo Zucchi, drawing for *The Golden Age*, c. 1565. Pen, brown ink,
      brown and ocher wash, and white bodycolor on ocher paper, 18 ⅞ ×
      14 ⅞ inches | 47.9 × 37.8 cm. J. Paul Getty Museum, Los Angeles

79    Jacopo Zucchi, *The Golden Age*, c. 1570. Paint on wood, 19 ¾ × 15 ⅛
      inches | 50 × 38.5 cm. Galleria degli Uffizi, Florence

PISSING GIRLS

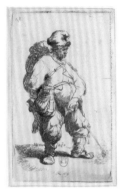

80    Jacopo Zucchi, *The Silver Age*, c. 1570. Paint on wood, 19 ¾ × 15 ⅛ inches |
        50 × 38.5 cm. Galleria degli Uffizi, Florence

81a   Rembrandt, *Pissing Man*, 1631. Etching, 3 ¼ × 1 ⅝ inches | 8.3 × 4 cm;
        b. *Pissing Woman*, 1631. Etching, 3 ¼ × 2 ½ inches | 8.1 × 6.4 cm. Prints
        and Photographs Department, Bibliothèque Nationale de France, Paris

82    Jacques Callot, *Les Caprices: Landscape with a Crouched Peasant,*
        *Defecating and Urinating*, c. 1617. Etching, 2 ⅜ × 3 ¼ inches | 5.9 × 8.1 cm.
        British Museum, London

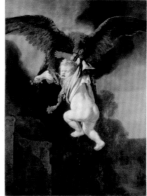

83    Utagawa Kuniyoshi, plate from the album *Ôeyama*, 1831. Three-volume
       xylograph, each page 8⅝ × 5⅞ inches | 22 × 15 cm. Nichibunken, Kyoto

84    Takashi Murakami, *My Lonesome Cowboy*, 1998. Epoxy resin, 100 ×
       45⅝ × 35⅞ inches | 254 × 116 × 91 cm. Private collection

85    Rembrandt, *Rape of Ganymede*, 1635. Oil on canvas, 67⅜ × 52 inches |
       171 × 132.3 cm. Gemäldegalerie Alter Meister, Staatliche Kunstsamm-
       lungen Dresden. Photo: Hans-Peter Klut

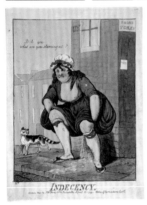

86   Unsigned, *Pisser*, c. 1900. Polychrome. Private collection
87   Unsigned photograph from the series *Parisian Pissers*, c. 1910.
     Private collection
88   Isaac Cruikshank, *Indecency*, 1799. Colored etching. Prints &
     Photographs Division, Library of Congress, Washington, DC
89   Jean-Jacques Lequeu, *Ah! Elle s'écoute*, c. 1790–1795. Pen and black
     wash, 20 ⅝ × 16 ⅜ inches | 52.5 × 41.5 cm. Staatliche Kunsthalle
     Karlsruhe. Photo: Annette Fischer/Heike Kohler

PISSING GIRLS

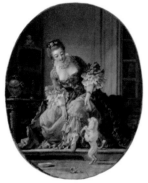

90a  François Boucher, *La femme qui pisse ou L'Œil indiscret*, c. 1742–1765.
Oil on canvas, 20 ⅔ × 16 ⅓ inches | 52.5 × 41.5 cm. Private collection.
Photo: Christian Baraja; b. detail

90c  François Boucher, *The Learned Dog*, c. 1740. Oil on canvas, unframed:
20 ⅔ × 16 ⅓ inches | 52.5 × 41.5 cm; framed: 33 ⅓ × 21 ⅔ × 2 ⅕ inches |
77 × 55 × 7 cm. Inv. No. 2468. Staatliche Kunsthalle Karlsruhe.
Photo: Annette Fischer/Heike Kohler. Photo Credit: bpk Bildagentur /
Art Resource, NY

PISSING GIRLS

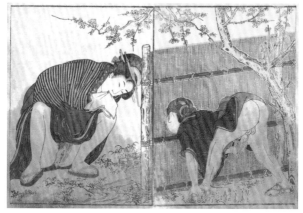

91a Utagawa Kunisada, plate from the album *Hyakki yagyô* (*Night Parade with One Hundred Demons*), 1825. Vol. 2/3, pl. 4. Xylograph, each page 8¾ × 6 inches | 22.3 × 15.4 cm. Ritsumeikan University Library, Kyoto; b. pl. 5
92 Kitagawa Utamaro, plate from the album *Ehon takara-kura*, 1800. Xylograph, each page 8½ × 5⅞ inches | 21.5 × 15 cm. Nichibunken, Kyoto

PISSING GIRLS

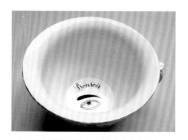

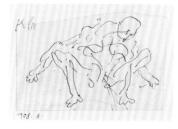

93 Unsigned bride's vase, fourteenth century. Lunéville faience, 8 7/10 inches | 22 cm. Private collection

94 Pablo Picasso, *A Urinating Woman Surprised by the Elders*, October 25, 1966. Aquatint, 10 3/4 × 14 4/5 inches | 27.2 × 37.6 cm. Inv. No. M P1990-135bis. Musée Picasso, Paris, France. Photo: Thierry Le Mage. © RMN-Grand Palais / Art Resource, NY

95 Paul Klee, *Female Nude Relieving Herself*, 1908. Pen on paper pasted on cardboard, 2 1/4 × 3 1/2 inches | 5.7 × 8.9 cm. Zentrum Paul Klee, Bern

PISSING GIRLS

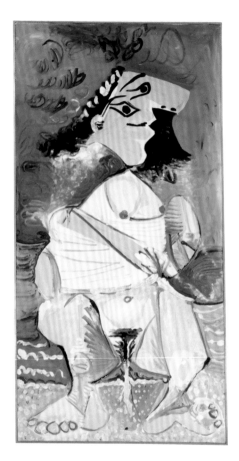

96    Pablo Picasso, *La pisseuse*, 1965. Oil on canvas, 76 ²⁄₃ × 38 inches |
      194.8 × 96.5 cm. Inv. No. 1984 CX 0429. Musée National d'Art Moderne,
      Centre Georges Pompidou, Paris, France. Photo: DR. © ARS, NY
      © CNAC/MNAM/Dist. RMN-Grand Palais / Art Resource, NY

PISSING GIRLS

97    Gilles Berquet, *The Pisser*, 2000. Gelatin silver print, 7 ⅞ × 7 ⅞ inches | 20 × 20 cm. Private collection

98    Claude Fauville, *Pisser*, 1999. Gelatin silver print, 7 ⅞ × 7 ⅞ inches | 20 × 20 cm. Private collection

99    Sophy Rickett, *Pissing Woman (test)*, 1994. Gelatin silver print, 13 ¾ × 9 ⅞ inches | 35 × 25 cm. Private collection

PISSING GIRLS

100  Itziar Okariz, *Mear en espacios públicos o privados*: *Subway* (still), 2002. Video, color, sound, 7 min.

101  Kiki Smith, *Pee Body*, 1992. Wax and glass pearls (23 strands of varying lengths, from 12 inches | 30.5 cm to over 180 inches | 457.2 cm long), 27 × 28 × 28 inches | 68.6 × 71.1 × 71.1 cm. Harvard Art Museums/Fogg Museum, Cambridge, Massachusetts

102  Marlene Dumas, *Peeing with a Blue Dress On* (*meisie piepi/in blou rok*), 1996. India ink wash and acrylic on paper, 24 ⅜ × 19 ¾ inches | 62 × 50 cm. Private collection, New York

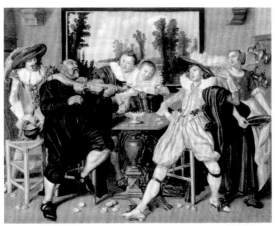

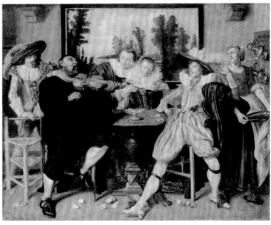

103a Willem Buytewech, *Merry Company* (after restoration), c. 1622–1624. Oil on canvas, 25 ⅝ × 32 ⅛ inches | 65 × 81.5 cm. Gemäldegalerie, Staatliche Museen, Berlin. Photo: Jörg P. Anders; b. before restoration

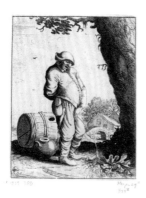

104   Willem Basse, *Pissing Peasant*, n.d. Etching, 5 ½ × 4 ⅜ inches | 14 × 11 cm.
Rijksmuseum, Amsterdam

105   Gerard ter Borch, *Pissing Cavalier*, 1631. Ink on paper, 3 ½ × 2 ⅜ inches |
9 × 5.9 cm. Rijksmuseum, Amsterdam

106   Attributed to the Bolognese School, *Elderly Man Urinating against a
Wall*, c. 1595–1600. Pen, brown ink, and brown wash, 10 ¼ × 7 ⅛ inches |
26 × 18 cm. Musée Bonnat-Helleu, Bayonne. Photo: A.Vaquero

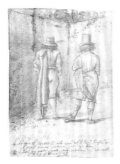

107  Pier Francesco Mola and Niccolo Simonelli, *Mola and Simonelli Pissing in the Villa Pamphili Gardens*, 1649. Ink, crayon, and graphite on paper, 8 ⅝ × 6 ⅛ inches | 22 × 15.6 cm. Rijksmuseum, Amsterdam

108  Thomas Bewick, illustration from Ralph Beilby, *A History of British Birds*, vol. 1 (Newcastle: Beilby & Bewick, 1797), p. 42. Engraving in wood, 1 ¾ × 3 ⅛ inches | 4.4 × 7.9 cm. British Museum, London

109  Paul Gauguin, *Te Poipoi*, 1892. Oil on canvas, 26 ¾ × 36 ¼ inches | 68 × 92 cm. Private collection, Hong Kong

110    James Ensor, *The Pisser, or A Man of the People*, 1887. Etching, 5 ⅝ ×
       4 inches | 14.3 × 10.1 cm. Kreeger Museum, Washington, DC
111ab Paul McCarthy, *In Nature* (details), 2009. Drawings for *WHITE SNOW*,
       Hauser & Wirth, New York, 2009, 18 ½ × 93 ¼ inches | 47 × 237 cm.
       Hauser & Wirth, New York

MODERNITIES

112  Kurt Kren, *20. September* (still), 1967. Black-and-white 16mm film,
     silent, 6 min.
113  Otto Muehl, *Piss Action*, September 7, 1969. Performance.
     Occamstudio, Munich
114  Andres Serrano, *A History of Sex (Leo's Fantasy)*, 1996. Cibachrome
     print, Diasec mounting, 40 × 32 ½ inches | 101.6 × 82.6 cm.
     Private collection

MODERNITIES

115   Andres Serrano, *Immersion (Piss Christ)*, 1987. Cibachrome print, Plexiglas, 59 ⅞ × 40 ⅛ inches | 152 × 102 cm. Private collection

116   Charles Demuth, *Three Sailors*, c. 1930. Watercolor and crayon on paper, 8 ½ × 9 ⅜ inches | 21.6 × 23.8 cm. Private collection

117   Sadao Hasegawa, *Gon Gu Edu 11* ( *Joyfully Seeking the Impure Land 11*), 1981. Offset print, 14 ⅞ × 10 ⅝ inches | 37.7 × 27 cm. Gallery Naruyama Collection, Tokyo

118    Norbert Bisky, *The Artist at Work*, 2005. Oil on canvas, 78 ¾ × 98 ⅜ inches |
       200 × 250 cm. Private collection. Photo: Bernd Borchardt
119    Marwane Pallas, *Unload*, 2013. Photomontage, Diasec mounting,
       39 ⅜ × 39 ⅜ inches | 100 × 100 cm. Private collection

MODERNITIES

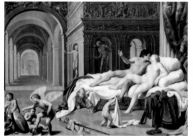

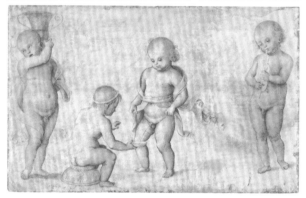

120   Carlo Saraceni, *Venus and Mars*, c. 1600. Oil on copper, 15 ½ × 21 ⅝
      inches | 39.5 × 55 cm. Museo Thyssen-Bornemisza, Madrid

121   Circle of Annibale Carracci, *Young Man Urinating (Un putto che urina)*, n.d.
      Black chalk, brown ink, pen, and brown and gray wash, 10 ⅘ × 8 inches |
      27.5 × 20.4 cm. Inv. No. 7300-recto. Musée du Louvre, Paris, France.
      Photo: Richard Lambert. © RMN-Grand Palais / Art Resource, NY

122   Attributed to Pietro Perugino, *Four Children*, c. fifteenth–sixteenth
      centuries. Drawing, 9 ⅓ × 14 ½ inches | 23.3 × 36.8 cm. Inv. No. 777DR.
      Musée du Louvre, Paris, France. Photo: Thierry Le Mage.
      © RMN-Grand Palais / Art Resource, NY

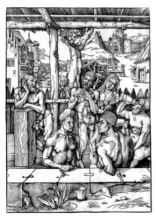

123 Albrecht Dürer, *The Men's Bath*, c. 1496. Xylograph, 15 ¼ × 11 ⅛ inches | 38.8 × 28.2 cm. British Museum, London

124 Gustave Doré, illustration from *Gargantua*, in *Œuvres de François Rabelais*… (Paris: J. Bry Aîné, 1854), p. 68. Bibliothèque Nationale de France, Paris

AMBIVALENCES

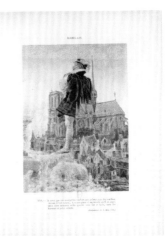

125 Jean-Jacques Grandville, illustration from Jonathan Swift, *Gulliver's Travels* (Paris: Furne & Cir/H. Fournier Aîné, 1838), p. 73. Bibliothèque Nationale de France, Paris

126 Jules Garnier, illustration from *Gargantua*, in *Rabelais et l'œuvre de Jules Garnier* (Paris: E. Bernard, 1897). Inv. No. RES G-Y2-30 Planche XIV. Bibliothèque Nationale de France, Paris. © RMN-Grand Palais / Art Resource, NY

AMBIVALENCES

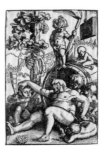

127   Attributed to Reyer Jacobsz van Blommendael, *Socrates, His Two Spouses, and Alcibiades*, c. 1655. Oil on canvas, 79 ⅛ × 78 inches | 201 × 198 cm. Museum of Fine Arts, Strasbourg

128   Pierre Brebiette, *Amours Playing Tricks on a Satyr and Bacchant*, n.d. Drawing, 6 ⅕ × 8 ⁷⁄₁₀ inches | 15.7 × 22.2 cm. Inv. No. 975-4-567A. Musée de Beaux-Arts, Rouen, France. Photo: René-Gabriel Ojéda. © RMN-Grand Palais / Art Resource, NY

129   Hans Baldung Grien, *Drunken Bacchus with Playing Putti*, c. 1520. Xylograph on paper, 8 ¾ × 6 inches | 22.2 × 15.4 cm. British Museum, London

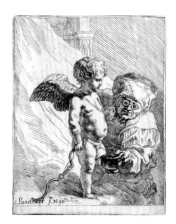

130 Joachim von Sandrart, *Cupid Pissing*, 1640. Etching, 5 ¾ × 4 ½ inches | 14.7 × 11.5 cm. British Museum, London

131 Unsigned box, c. 1800. Oil on wood with tortoiseshell edge, 3 ¾ inches | 9.4 cm. Private collection

AMBIVALENCES

132 Facsimile of an engraving by SL, based on a drawing by M,
   illustration from Eduard Fuchs, *Illustrierte Sittengeschichte*, vol. 1
   (Munich: Albert Langen, 1909), p. 274

133 Jörg Breu the Elder, illustration from Johann von Schwarzenberg,
   *Das Büchlein vom Zutrinken*, in *Der Teutsch Cicero* (Augsburg: Steiner,
   1534), fol. 92r. Xylograph. Bayerische Staatsbibliothek, Munich

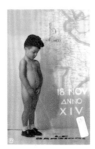

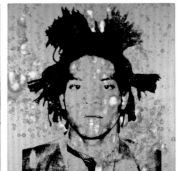

134a Unsigned fascist postcard, 1936. Private collection

134b Unsigned postcard, c. 1914–1918. Ed. A. Noyer, Iso Platine, "Patriotic" series, no. 1068, Paris. Postcard Museum, Antibes. Photo: Christian Deflandre

135 Małgorzata Szydłowska and Bartosz Szydłowski, *The Fountain of the Future (Lenin)*, 2014. 26 ¾ inches | 68 cm. Nowa Huta Museum, Kraków

136 Andy Warhol, *Oxidation Painting*, 1978. Copper pigment and urine on canvas, 76 × 52 inches | 193 × 132 cm. Private collection

137 Andy Warhol, *Jean-Michel Basquiat*, 1982. Acrylic, urine, and screen print on canvas, 40 × 40 inches | 101.6 × 101.6 cm. Brandt Foundation Art Study Center, Greenwich, Connecticut

PISSED ART

## ACKNOWLEDGMENTS

Whenever I told friends and acquaintances, even total strangers, that I was researching images of people pissing, they always insisted, spontaneously or otherwise, on furnishing me with information or images. I'd particularly like to thank Carel Blotkamp, Ricard Bru i Turull, Augustin de Butler, Guillaume Cassegrain, Andrew Chen, Philippe Comar, Judith Delfiner, Patrick Fischer, Francesco Galluzzi, Didier Girard, Patrick de Haas, Arno Haijtema, Emma Hall, Patrick Javault, Anouk Jevtić, Miya Mizuta Lippit, Éric Michaud, David Monteau, Gabriel Montua, Neil Printz, Jean Louis Schefer, Alberto Sorbelli, Ilja Veldman, Françoise Viatte, Reva Wolf, Christopher Wood, Mauro Zanchi, Henri Zerner.

JEAN-CLAUDE LEBENSZTEJN is a French art historian, critic, and honorary professor at the University of Paris 1 Panthéon-Sorbonne. His interests range from the art of the eighteenth and twentieth centuries to film, music, human animality, and, more generally, the question of frontiers and boundaries. In addition to his *Études cézanniennes* (2006) and a scholarly edition of fifty-three of Cézanne's letters (2011), Lebensztejn has recently published *Déplacements*, a collection of his essays concerned with questioning norms of taste and aesthetic values, as well as a translation of Lao Tzu, a study of Pygmalion, and a conversation with Malcolm Morley. His most recent book, on transgression in the works of Franz Kafka, the Marquis de Sade, and the Comte de Lautréamont, was published in 2017.

JEFF NAGY is a translator, critic, and historian of technology based in Palo Alto, California. His research focuses on networks pre- and post-Internet and the development of digital labor.

"Ekphrasis" is traditionally defined as the literary representation of a work of visual art. One of the oldest forms of writing, its meaning originated in ancient Greece, where it referred to the practice and skill of describing people, objects, and experiences through vivid, highly detailed accounts. Today, ekphrasis is more openly interpreted as one art form, whether it be writing, visual art, music, or film, being used to define and describe another art form, in order to bring to the audience the experiential and visceral impact of the subject.

By bringing back into print important but overlooked books—often pieces by established artists and authors—and by commissioning emerging writers, philosophers, and artists to write freely on visual culture, David Zwirner Books aims to encourage a richer conversation between the worlds of literary and visual art. With an emphasis on writing that isn't academic in the traditional sense, but compelling as prose, and more concerned with subject matter than historical reference, *ekphrasis* invites a broader and more varied audience to participate in discussions about the arts. Particularly now, as visual art becomes an increasingly important cultural touchstone, creating a series that encourages us to make meaning of what we see has become more compelling than ever. Books in the *ekphrasis* series remind us, with refreshing energy, why so many people have dedicated their lives to art.

OTHER TITLES IN THE *EKPHRASIS* SERIES

*Ramblings of a Wannabe Painter*
Paul Gauguin

*Degas and His Model*
Alice Michel

*Chardin and Rembrandt*
Marcel Proust

FORTHCOMING IN 2017

*Summoning Pearl Harbor*
Alexander Nemerov

*Letters to a Young Painter*
Rainer Maria Rilke

*Pissing Figures 1280–2014*
Jean-Claude Lebensztejn

Translated from the French
*Figures pissantes 1280–2014*

Published by
David Zwirner Books
529 West 20th Street, 2nd Floor
New York, New York 10011
+ 1 212 727 2070
davidzwirnerbooks.com

Editor: Lucas Zwirner
Translator: Jeff Nagy
Project Assistant: Molly Stein
Proofreader: Clare Fentress

Design: Michael Dyer / Remake
Production Manager: Jules Thomson
Printing: VeronaLibri, Verona

Typeface: Arnhem
Paper: Holmen Book Cream, 80 gsm;
GardaMatt, 130 gsm

Publication © 2017
David Zwirner Books

Text © 2017 Jean-Claude Lebensztejn
Translation © 2017 Jeff Nagy

Special thanks to Éditions Macula
who published the original
French in 2016

Distributed in the United States
and Canada by
ARTBOOK | D.A.P.
75 Broad Street, Suite 630
New York, New York 10004
artbook.com

Distributed outside the
United States and Canada by
Thames & Hudson, Ltd.
181A High Holborn
London WC1V 7QX
thamesandhudson.com

ISBN 978-1-941701-54-6
LCCN 2017937790

David Zwirner Books

*ekphrasis*